HALSMAN AT WORK

PHILIPPE HALSMAN AND
YVONNE HALSMAN

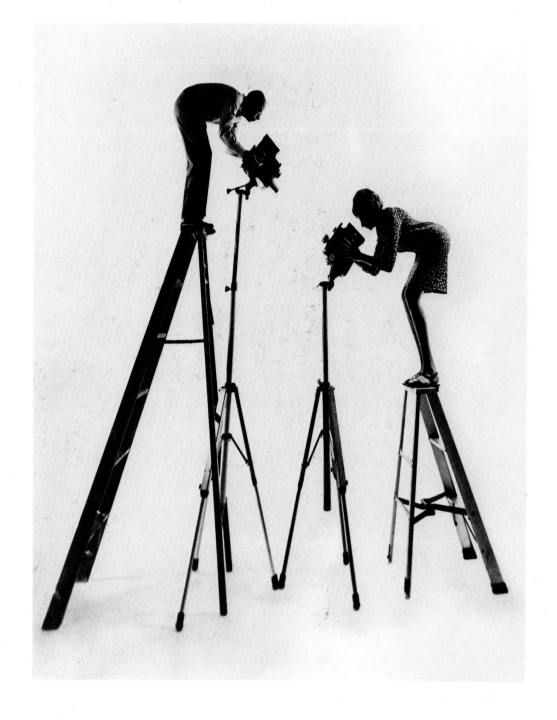

BY YVONNE HALSMAN

HALSMAN AT WORK

PHILIPPE HALSMAN AND YVONNE HALSMAN

HARRY N. ABRAMS, INC.,
PUBLISHERS, NEW YORK

FOR IRENE, JANE, STEVE, JENNIFER, SOPHIE, AND OLIVER, WITH LOVE

Editor: Eric Himmel
Designer: Bob McKee
Assistant Designer: Laura Lovett

Library of Congress Cataloging-in-Publication Data
Halsman, Yvonne.
Halsman at work / text by Yvonne Halsman; photographs by Philippe Halsman.
p. cm.
ISBN 0-8109-2436-6
1. Photography—Portraits. 2. Halsman, Philippe. I. Halsman, Philippe. II. Title.
TR681.F3H357 1989
770'.92'4—dc19 89-211
CIP

All of the photographs in this book were taken by Philippe or Yvonne Halsman, except for the following: Assistants to Philippe Halsman, pages 6 (bottom left), 44 (top), 46 (top), 52 (top), 64; Gene Cook, page 93 (bottom); Dan Kramer, page 9 (bottom right).

Copyright © 1989 Yvonne Halsman
Published in 1989 by Harry N. Abrams, Incorporated, New York
A Times Mirror Company
Printed and bound in Japan

Opposite: Returning from an outing at the beach one afternoon in 1958, we noticed this weird
dancing tree. Philippe put on his fisherman's cap and paid homage to the tree.
Preceding spread: After a complicated and difficult sitting in the studio where Philippe used
two ladders for the job, he had this idea for our 1967 Christmas card.—Y.H.

CONTENTS

INTRODUCTION

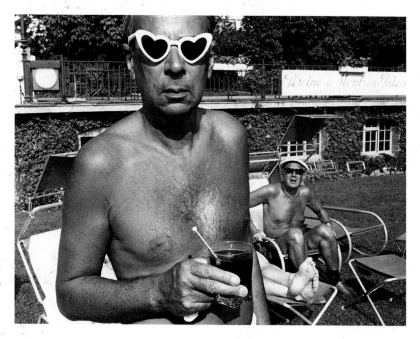

In 1968 Philippe and I made our second trip to Montreux, Switzerland, to photograph Vladimir Nabokov for the *Saturday Evening Post*. The film version of Nabokov's book, *Lolita,* had recently opened, and Nabokov and his wife Vera had a pair of the famous heart-shaped sunglasses from the film. Philippe and Vladimir, who had become good friends, were strolling in the garden of the Montreux Palace Hotel deep in an animated discussion of Russian literature. At one point, Philippe turned to Vera who was wearing Lolita sunglasses and asked if he might try them on. I couldn't resist grabbing the Nikon and recording this unique moment.

Some Halsman greeting cards

1952

1957

1956

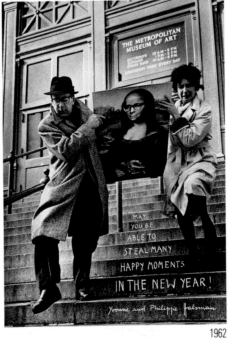

1962

Years later, after Philippe's death in 1979, I was invited to give a slide-talk before a professional photo association in New York about how Philippe made some of his best-known pictures. This invitation prompted me to search through our Nabokov file for the sunglasses picture and other photographs I had taken over the years of Philippe at work. Many of them existed only on contact sheets. As I gathered them, I was reminded how precious these pictures were to me because they provided a glimpse of how Philippe approached the challenges of his work, how he connected with his subjects, and how he accomplished what he did.

In the years since, I have been asked to give many more of these slide-talks, before museum groups, photographic seminars, and professional organizations such as the American Society of Magazine Photographers, of which Philippe was elected the first president in

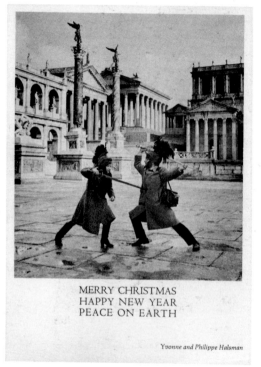

MERRY CHRISTMAS
HAPPY NEW YEAR
PEACE ON EARTH

Yvonne and Philippe Halsman

1963

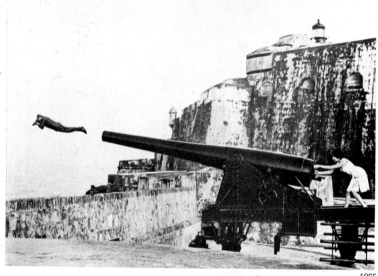

1965

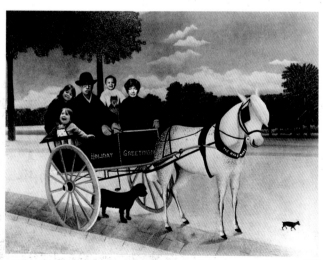

HOLIDAY GREETINGS

1976

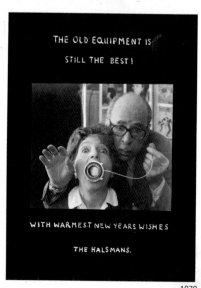

THE OLD EQUIPMENT IS
STILL THE BEST!

WITH WARMEST NEW YEARS WISHES
THE HALSMANS.

1978

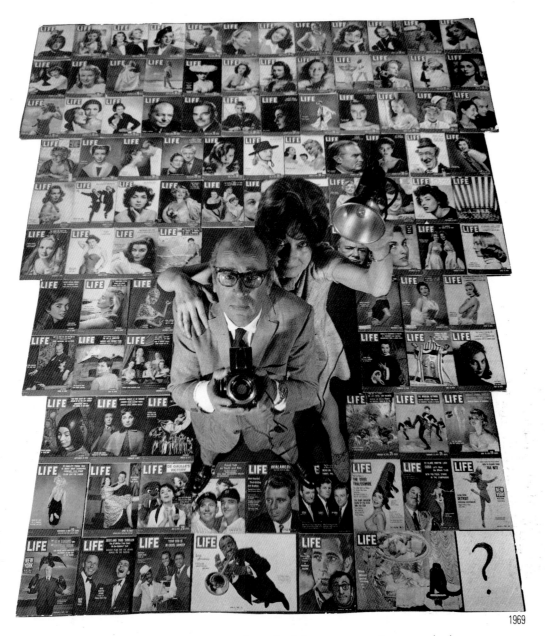

1969

1946. The talks have been so well received that many people approached me afterward and suggested that I see about having them published.

This little book is the result. I have included many of Philippe's own photographs, some of them never before published, as well as excerpts from his journals in which he talks about his creative philosophy. I have also added a few of the zany New Year's cards Philippe and I made together and sent out to our friends over the years.

I dedicate this book to the memory of the wonderful, stimulating, difficult, brilliant times I shared with my husband.

—Yvonne Halsman
January 1, 1989

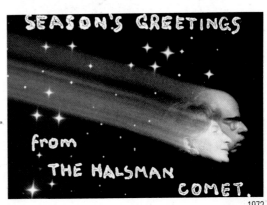

1973

PORTRAITS
THE DIRECT APPROACH

We all know the joke about the Frenchman who knew thirty-two different ways of lovemaking but had forgotten the natural one. Well, one should not be like this Frenchman. The first rule therefore is: Don't forget the natural or direct approach. Be straightforward. It is always the strongest. As strange as it may seem one often overlooks it. P.H.

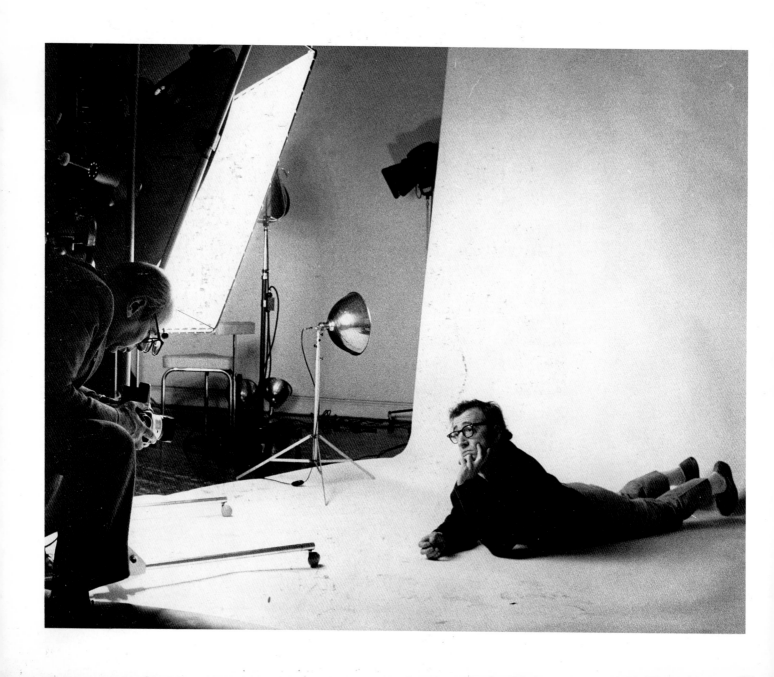

Woody Allen was photographed in our studio in 1969. He didn't say a word during the whole sitting. Philippe did all the talking. When Woody was lying on the floor, Philippe said to him, "I see, Woody, you only talk for money!" Woody thought for a while and then broke his silence: "Yes." Y.H.

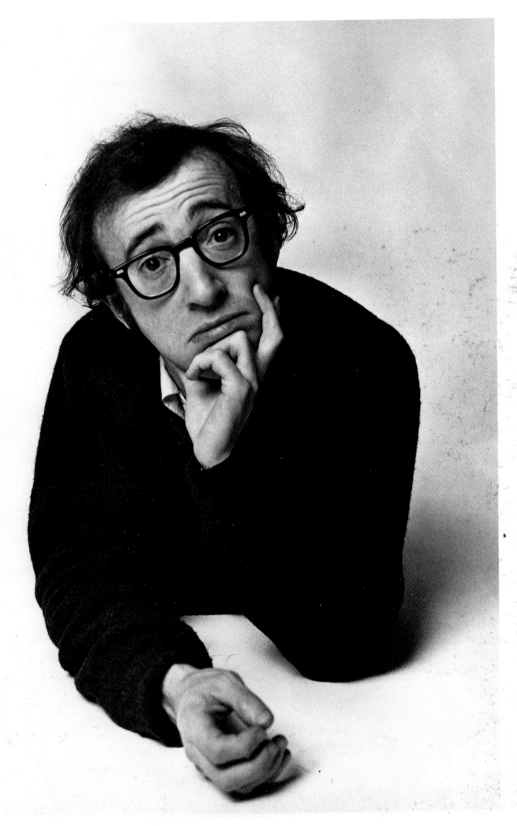

When he was elected president, Richard Nixon decided Philippe was the only photographer who could take his official portrait.

In early 1967, we went to his suite at the Hotel Pierre in New York with all our equipment. Nixon said he wanted to be photographed smiling. So Philippe said: "Fine, Mr. President, please smile!" Nixon answered: "First you must tell me a good joke."

Philippe glanced out the window that faced the Central Park Zoo, and an appropriate joke came to mind: "A lady in the zoo had been observing a hippopotamus for a long time. She finally went to the zookeeper and asked: 'Please, tell me, is it a male or a female?' The zookeeper looked at her gravely. 'Madam,' he answered, 'this is a question that should only interest another hippopotamus.'"

Nixon laughed so hard that for the rest of the sitting he continued to smile and mutter to himself, "Ah, that hippopotamus joke!"

Y.H.

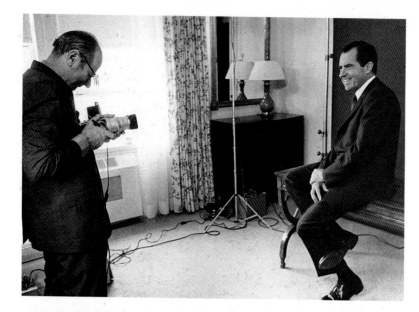

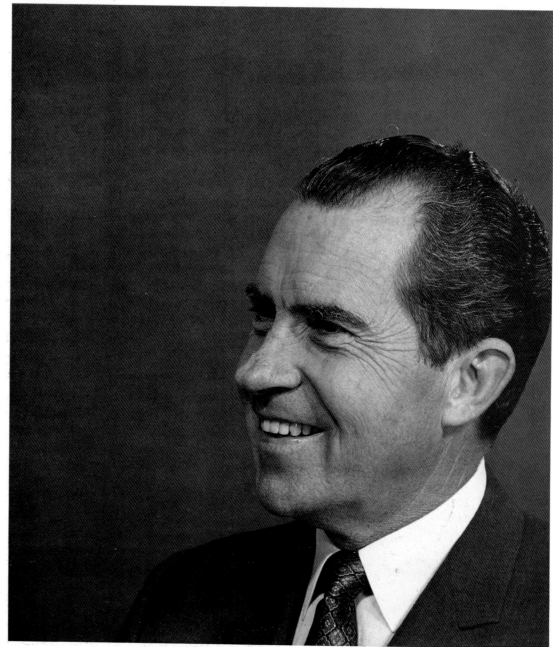

14

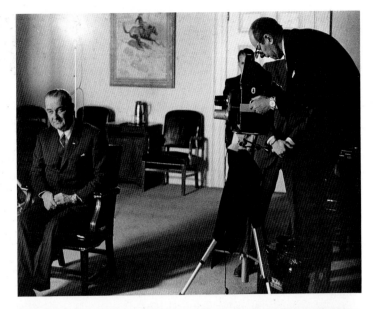

Newsweek assigned Philippe to photograph President Lyndon Johnson for a cover in 1964. We went to the White House with great expectations. It turned out that Johnson was boorish, and the sitting was disappointing and unpleasant. He entered the room with only the words, "Where shall I sit?" not even bothering to say hello.

After taking several shots of a sullen Johnson, who clearly wanted no conversation at all, Philippe suddenly said, "Thank you, Mr. President. I have all the pictures I need." Johnson was startled. Usually the photographer pleads for just one more shot.

Y.H.

I never try to impose my ideas on my subjects by forcing them into unfamiliar poses, changing the tilt of their heads, or arranging their hands. I want them to be as they are. But I want to make my statement also with clarity and strength. For instance, I don't consider lighting as something one measures with a light meter in order to find the right exposure. I want my light to be so that in a two-dimensional print it gives us the feel of the third dimension, that it shows volume and depth. However, above all, I consider light as a means of characterization. Light can be soft and it can be harsh. It would be foolish to weaken the strength of a face with flat and diffused light or to use dramatic lighting to show a tender and peaceful expression.

P.H.

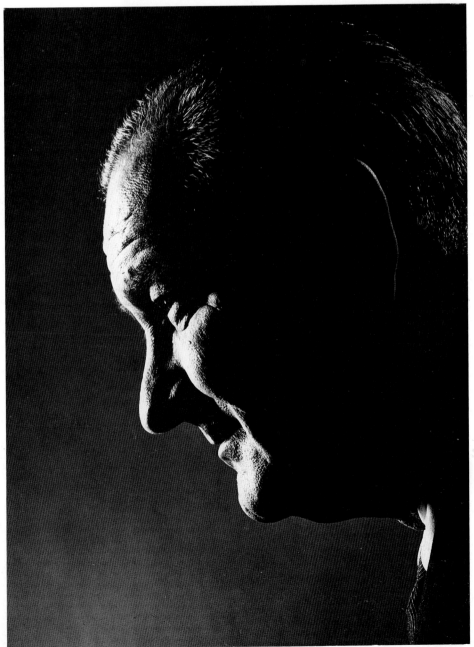

Philippe photographed André Malraux for the first time in 1934 in Paris. He was then assisted by his German girlfriend.

Philippe photographed him again in Paris in 1966 on the terrace of the Ministry of Culture at the Palais Royal. This time I was the assistant. Malraux greeted me warmly, clasping my hand. "I remember you very well," he said with the old Gallic gallantry.

Y.H.

The two sides of his face were dissimilar—according to Lombroso, a sign of either genius or criminality. Seen from the left his profile had an aquiline nobility; from the right, it looked less romantic because his nose suddenly took on the shape of a duck's bill. Malraux's eyes fixed my lens with an almost unbearable intensity and intelligence.

P.H.

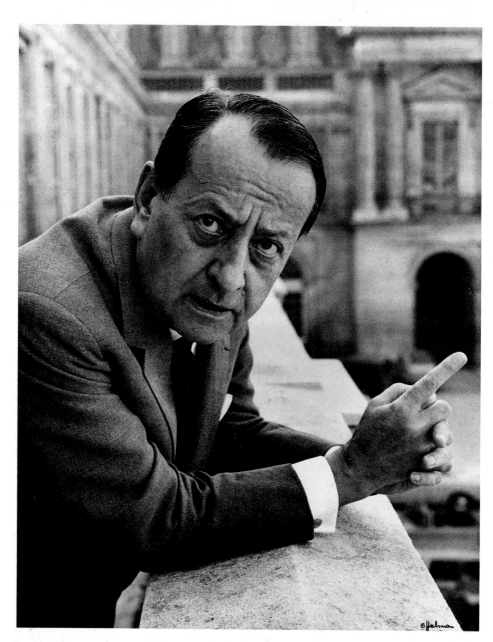

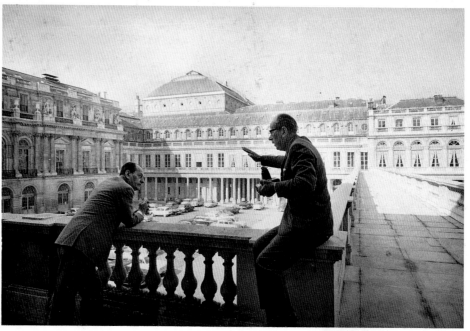

Jean-Paul Sartre did not want to pose for *Life* because he didn't agree with the magazine's opinions. But when he heard that Philippe was a freelancer who wanted to photograph him for himself, Sartre agreed to sit.

Sartre was photographed in 1951 in his apartment overlooking Place St. Germain des Prés. After a few shots Philippe moved the front light so that he could place the shadow from the frames of Sartre's glasses across his right walleye.

When Sartre saw his portraits he was very pleased and asked for a print for his mother.

Y.H.

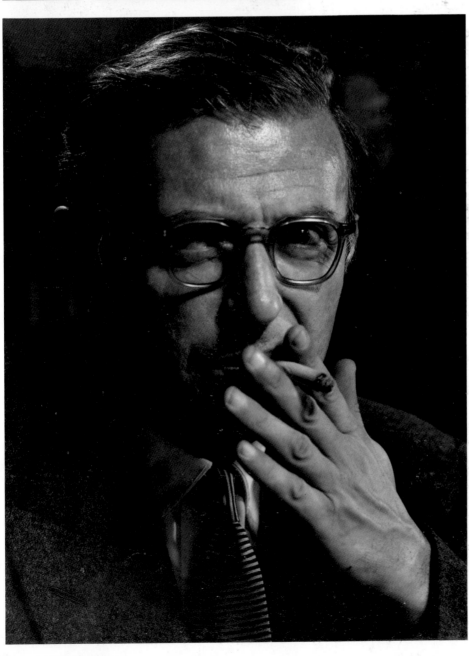

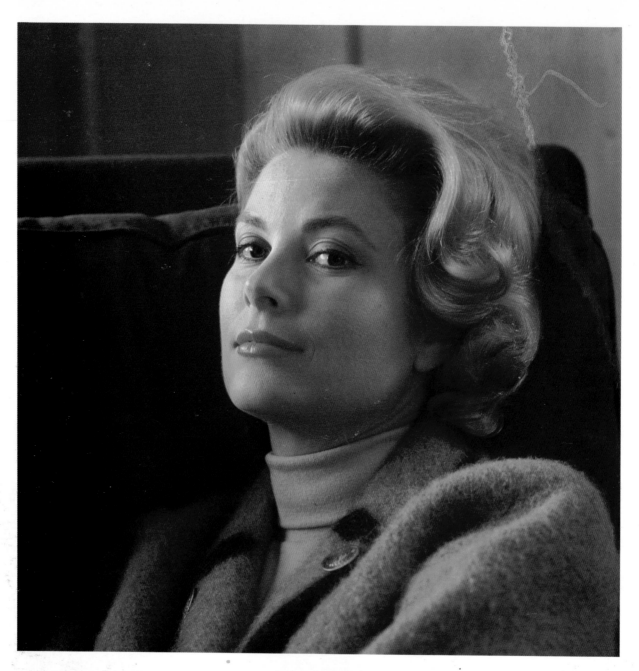

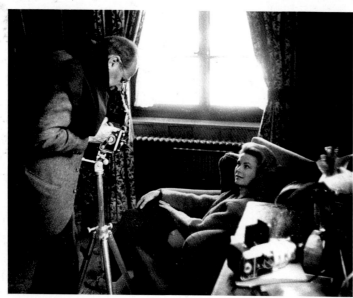

The black-and-white profile of Grace Kelly (right) was taken for a *Popular Photography* story entitled "How a Beautiful Girl is Shot for a *Life* Cover." In the early '50s, Grace Kelly was a starlet whom Philippe had seen and admired in *Mogambo*, starring Ava Gardner and Clark Gable.

In 1953, when *Popular Photography* asked Philippe to choose a model for the story, he immediately suggested the beautiful Grace Kelly, and she accepted with pleasure.

Philippe photographed Grace from many angles and thought of showing some of the enlargements to the editor at *Life*. The editor looked at the pictures and said, "Indeed, she is very beautiful, but who is she? We have already had too many unknown models on our cover."

The day the story appeared in *Popular Photography*, the editor at *Life* telephoned Philippe. "Why didn't you submit this fantastic-looking girl to *us*?" he asked furiously. Philippe answered diplomatically: "Oh, I'm sorry. I'll bring you the pictures tomorrow."

Within two weeks Grace Kelly's beautiful profile was on the cover of *Life*.

In 1962, Philippe again photographed Grace (opposite), who was now a princess, for the *Time* magazine story, "Reigning Beauties."

Y.H.

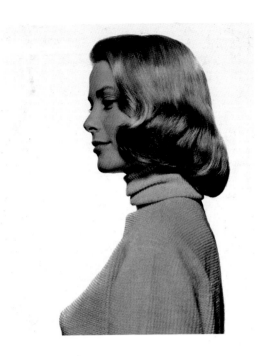

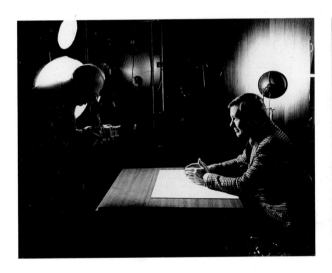

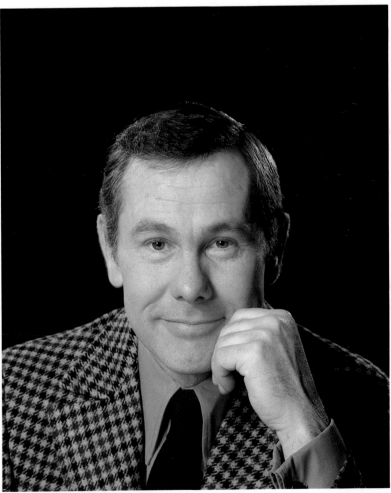

Philippe had photographed Johnny Carson many times for different magazines. This portrait was Philippe's historic one-hundredth cover for *Life* in 1969, and he described it, in the magazine, as the high point of his career: "It has taken me twenty-seven years to achieve this record and I like to think of it as the equal of Babe Ruth's. Luck, of course, has played a part."

Y.H.

Here's how Philippe solved the problem of photographing Louis Armstrong for a *Life* pullout cover. This portrait has become one of Philippe's best-known images.

Y.H.

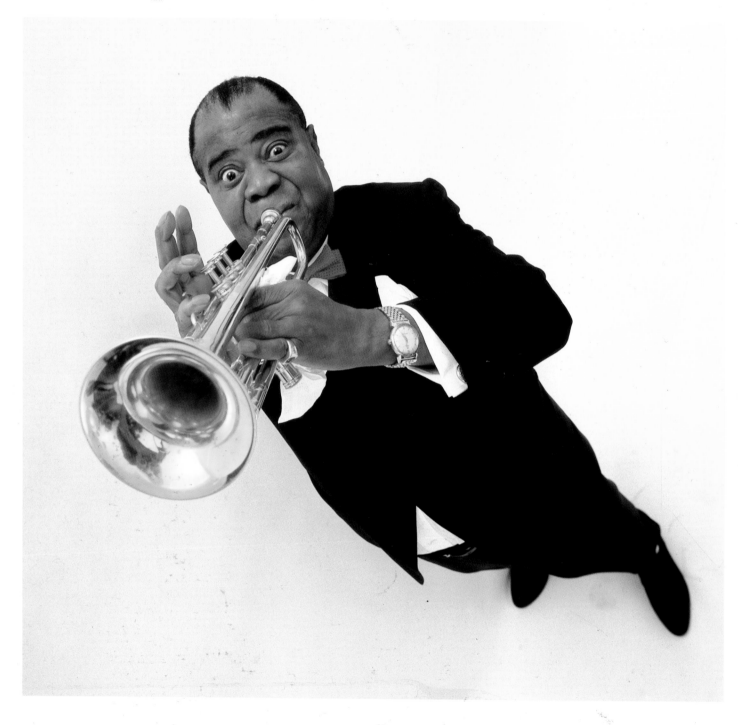

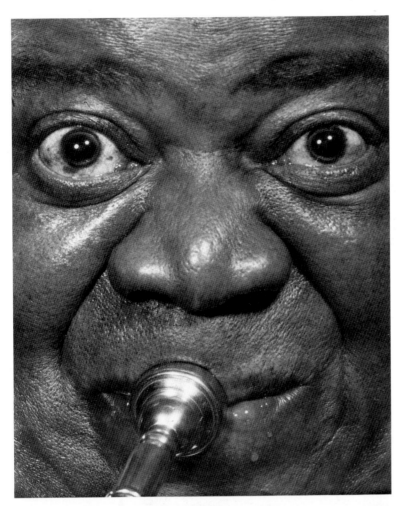

I continued my exploration of the interdependence of technique and emotional impact. I asked myself what would happen if I placed my subject in the upper or lower part of my picture, or if I reversed the negative, or if I changed the axis or cropping of my print. Eventually, in my striving for strength and intensity, I started to crop away unimportant parts of a face. I filled the rectangle of my print only with features that conveyed the expression. However, when I came to America and showed these pictures, my critics assured me that it was absolutely not permissible to crop away the forehead of a person, and I stopped doing it. A few years ago, this kind of cropping became acceptable and "modern" in the United States, proving again the saying that new is "what has been forgotten."

P.H.

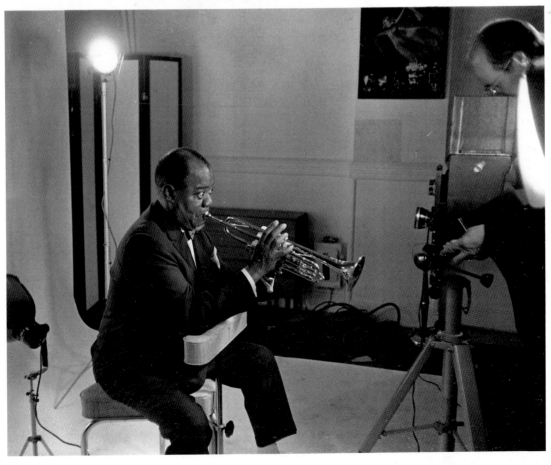

LEGENDS

Sometimes the photographer achieves the greatest reward of all: His photographic interpretation of a great human being becomes *the* definitive image of this being. A portrait that you have created becomes the very form in which he will live in history for future generations.

P.H.

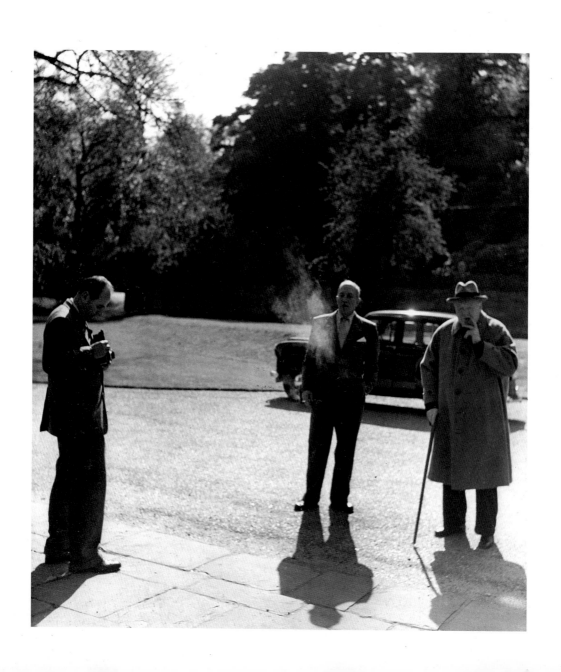

In the garden Churchill struck a rather brisk pace. I had to hurry to get ahead of him in order to have a good view of his face. The old boy noticed it, and suddenly his competitive instinct awoke. Since I was on his right, he turned and walked to his left. I hurried and appeared on his left. Churchill immediately turned to his right. He continued playing this cat-and-mouse game, which he obviously enjoyed more than I. Eventually he reached the edge of the garden and sat down on a small rock. His poodle Rufus installed himself behind Churchill's back.

Churchill sat looking at the beautiful, typically English rolling landscape in front of him. As far as he could see, it all belonged to him, bought with *Life* magazine's money, over $1 million for the rights to his memoirs. I knew that if I emerged and faced him, Churchill would turn away. I quietly selected my position and shot Churchill's back.

Of the close-ups that I made that day, one was used by Churchill on the jacket of his book as well as by *Life* on its cover. In it Churchill is captured with a forceful expression. I have filed away a couple of photographs that show the beginning of a fall and decline of his magnificent face. However, the most successful of all my photographs of Churchill turned out to be the view of his back, which I had shot almost out of desperation. It was widely reproduced, and it was shown as the closing image of each of the twenty-six episodes of the TV series *Churchill's Valiant Years*.

P.H.

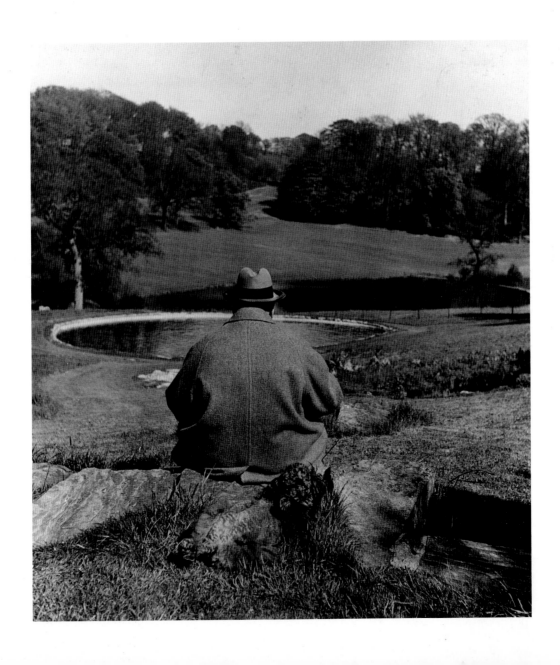

The question of how to capture the essence of such a man as Albert Einstein in a portrait filled me with apprehension. Finally, in 1947, I had the courage to bring on one of my visits my Halsman camera and a few floodlights. After tea, I asked for permission to set up my lights in Einstein's study. The professor sat down and started peacefully working on his mathematical calculations. I took a few pictures. Ordinarily, Einstein did not like photographers, whom he called *Lichtaffen* (light monkeys). But he cooperated because I was his guest and, after all, he had helped to rescue me. (After the fall of France, it was through his personal intervention that my name was added to the list of artists and scientists who, in danger of being captured by the Nazis, were given emergency visas to the United States.)

Suddenly, looking into my camera, he started talking. He spoke about his despair that his formula $E = mc^2$ and his letter to President Roosevelt had made the atomic bomb possible, that his scientific search had resulted in the death of so many human beings. "Have you read," he asked, "that powerful voices in the United States are demanding that the bomb be dropped on Russia now, before the Russians have the time to perfect their own?" With my entire being I felt how much this infinitely good and compassionate man was suffering from the knowledge that he had helped to put in the hands of politicians a monstrous weapon of devastation and death.

P.H.

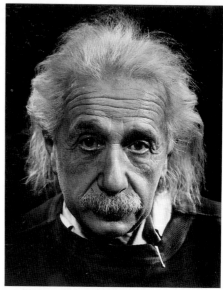

In 1951, although she had never had more than bit parts in movies, at my suggestion Life sent me to Hollywood to photograph Marilyn Monroe for a cover. The Life reporter, my assistant, and I drove to the outskirts of Los Angeles, where she lived in a cheap two-room apartment. What impressed me in its shabby living room was the obvious striving for self-improvement of this alleged dumb blonde. I saw a photograph of the Italian actress Eleonora Duse and a multitude of books that I did not expect to find there either, like the works of Dostoyevski, of Freud, the history of Fabian Socialism, etc. On the floor were two dumbbells. "Are you using them?" I asked. "Yes," she replied, "I am fighting gravity." Later, between two interminable dress changes, she appeared in a semitransparent negligee, and I complimented her for not needing a bra. "But Philippe!" she said, "I told you that I was fighting gravity."

I took hundreds of pictures. One of them, later widely used in gigantic blowups, showed her inimitable sexy walk from the rear.

Later she came to New York and visited my studio. I introduced her to my wife, and I realized then how much Marilyn was afraid of women. She thought that they resented her sex appeal, and she was convinced that all women despised and hated her. When Yvonne treated her kindly, Marilyn's response was touchingly grateful.

P.H.

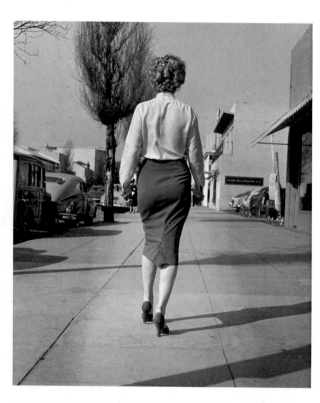

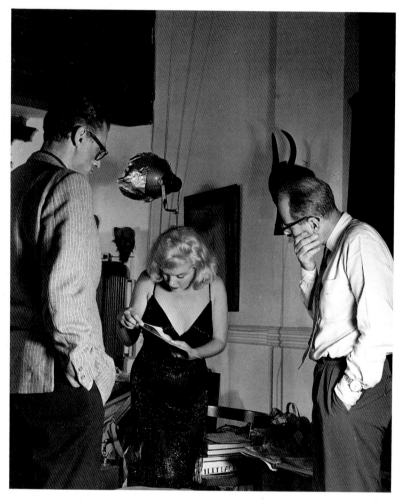

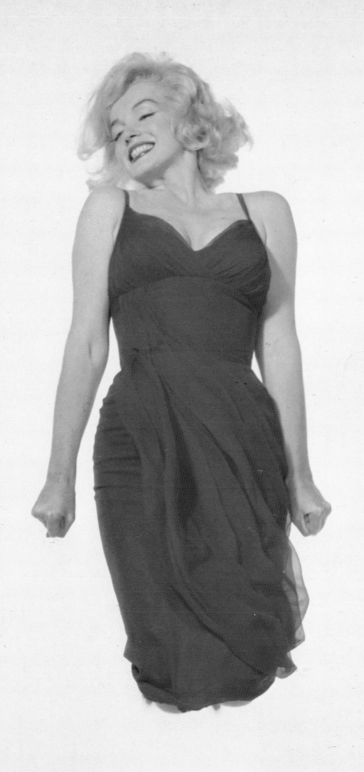

MORE PORTRAITS

I never was an apprentice or assistant to another photographer. Everything that I know I learned by trial and error and by a lot of experimenting. I consider every assignment as a problem and my picture as its solution. I don't belong to photographers who shoot out of instinct. A lot of thinking goes into my taking—or should I say making—pictures.

P.H.

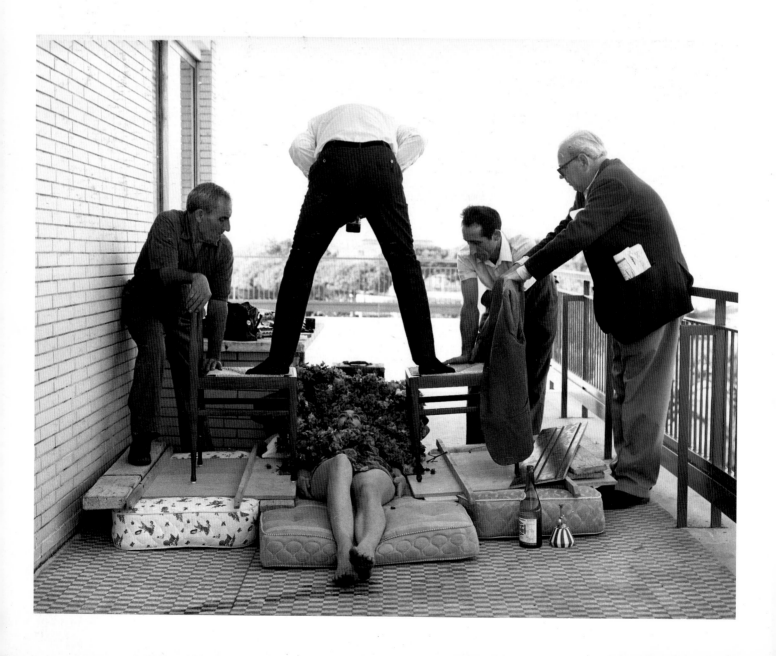

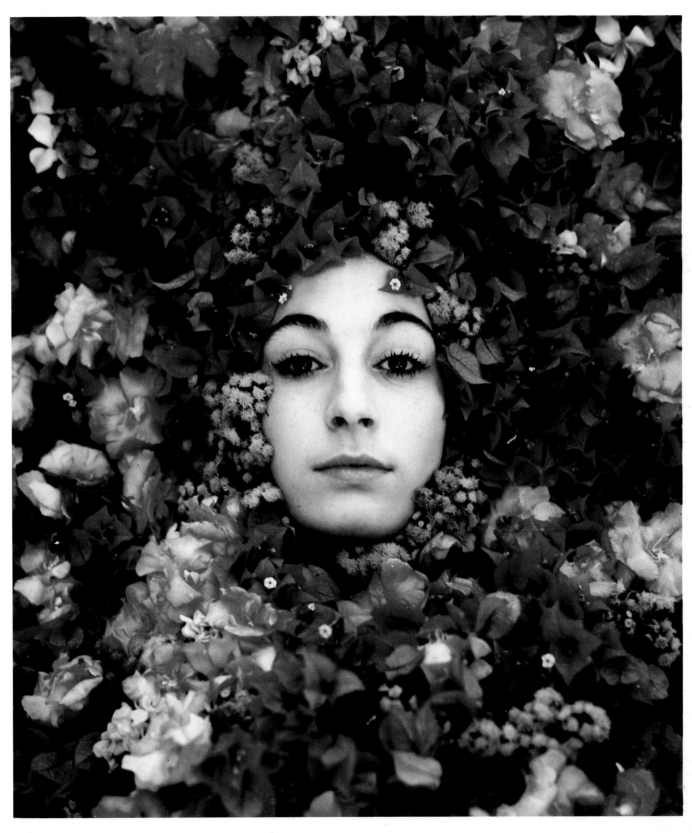

It is interesting to notice how photo-geneity has affected our ideal of feminine beauty. As we form our beauty standards from photographs of beautiful women, high cheekbones are now considered as a chief attribute of beauty. But only a hundred years ago Flaubert described Madame Bovary as attractive *"in spite of* her high cheekbones." All the Madonnas, goddesses, and nymphs of the Renaissance are not photogenic by today's standards. Raphael's mistress, who was his favorite model for Madonnas, had an oval flat face without prominent cheekbones. Were she alive today she would have no luck trying to work for a model agency. Among the Renaissance painters the only exception is Botticelli, whose every goddess, angel, and saint has the high cheekbones and the strong chin so dear to photographers and casting directors of today.

The change in our taste happened suddenly. It came with the introduction of artificial light in photographic and movie studios. The directional lighting sculpts dramatically a face with high cheekbones but flattens out a face without them into a broad blob. The result is that all famous film beauties, like Greta Garbo, Marlene Dietrich, Elizabeth Taylor, and Sophia Loren, have faces with the same bone structure. This bone structure guarantees a beautiful distribution of highlights and shadows in simple as well as in complicated lighting arrangements. It also guarantees a long career to the actress because it keeps the face taut and prevents the skin from sagging. Photogenic people look young longer than the rest of unphotogenic humanity.

P.H.

Here Philippe is suggesting a pose to Mrs. Patrick Guinness, of the noted British beer family, for a cover story in 1963 for *McCalls* entitled "Exclusive Portraits of the World's Most Elegant Women."

Y.H.

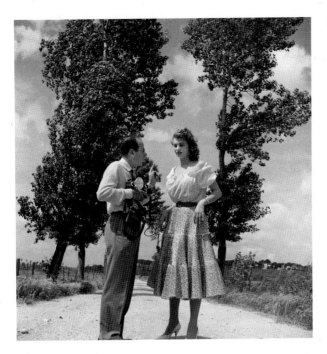

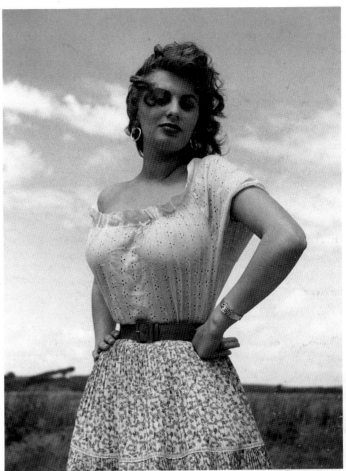

Philippe photographed the seventeen-year-old Sophia Loren in 1955 on the Via Appia near Rome. At that time she was a starlet working for the *fumetti*, weekly photo comic-strip magazines.

Y.H.

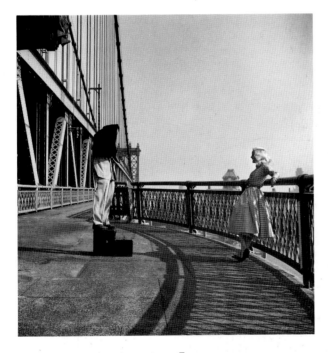

Eva-Marie Saint was photographed for the cover of *Life* magazine in 1954 on the Manhattan Bridge.

Y.H.

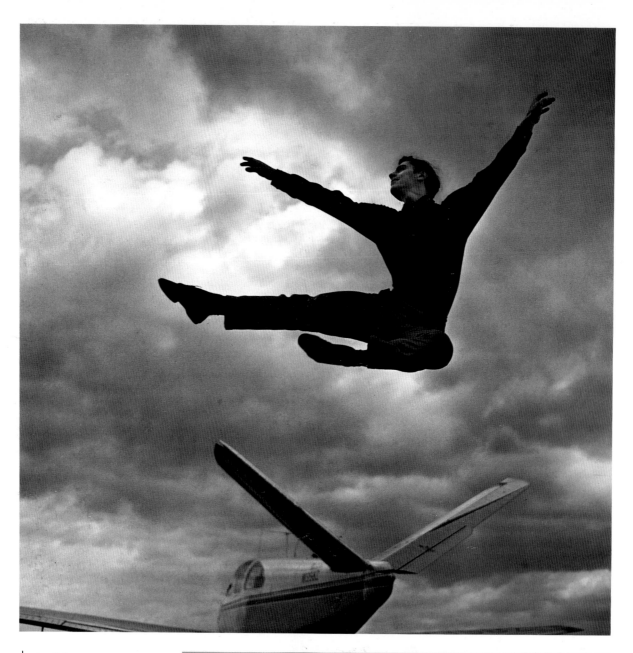

In 1961, Philippe had to photograph the famous dancer Edward Villela for a magazine. Since the dancer was also well known for his high jumps, Philippe decided to photograph him leaping over an airplane. It was a difficult shooting because Villela had to jump several times to get his legs in the correct position.

After the shooting, my ambitious Philippe said to me, "Let me try also. It can't be that hard."

Y.H.

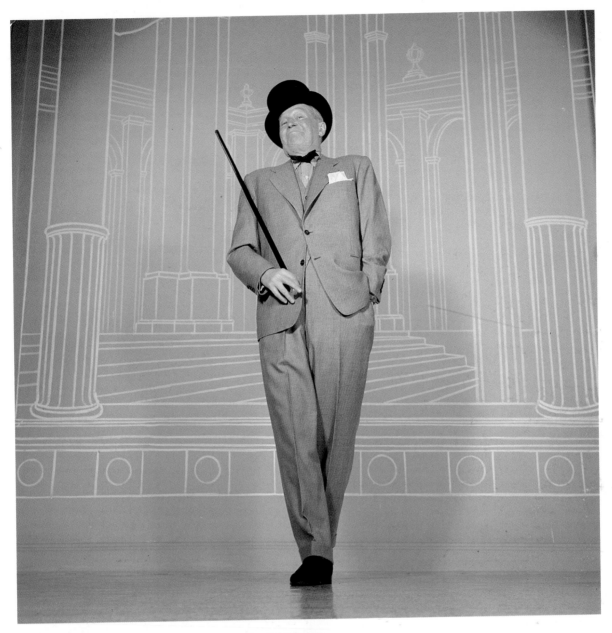

Maurice Chevalier gets some tips on cane technique from Philippe during this sitting for a *Life* cover in 1968.

Y.H.

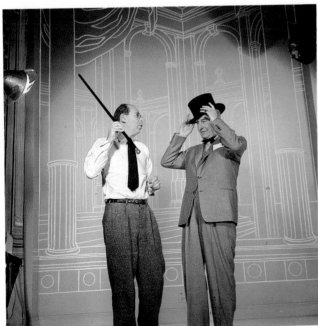

In 1969 I wanted to make a photograph that would fit the mood of Sammy Davis's autobiography. In it he describes his fight against prejudice—it was like going through a brick wall. Therefore, after making several portraits picturing Sammy in a thoughtful mood, I took him to our courtyard and photographed him half hidden behind a brick wall.

This was not the picture that made the jacket, but it is my favorite. First, it shows the brick wall he has had to face all his life. Secondly, the wall hides the glass eye Sammy acquired after a car accident. And lastly—since whenever I watch Sammy's boundless energy on the stage I have the feeling: It is too much!—I find it more soothing to contemplate half of Sammy Davis, Jr., than the whole of him.

P.H.

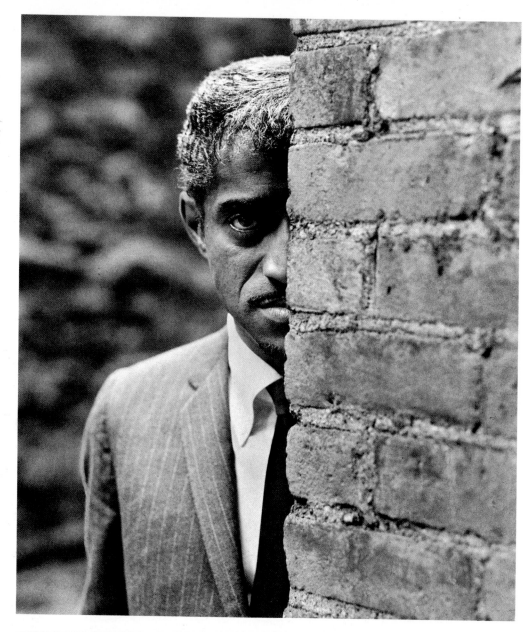

Leaping to Philippe's assistance is the very efficient Daniel Kramer, who has since gone on to a photographic career of his own.

Y.H.

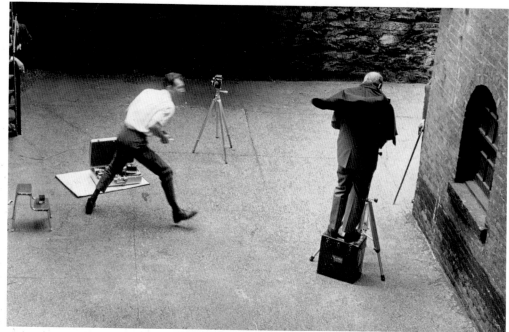

These pictures of Alma and Alfred Hitchcock, and Hitchcock's beloved dog Sarah, were taken at their home in Bel Air in 1975 as part of an assignment for the French edition of *Vogue*.

Since Hitchcock was a well-known gourmet, the French editor was eager to have Philippe photograph the contents of Hitch's refrigerator as well.

Y.H.

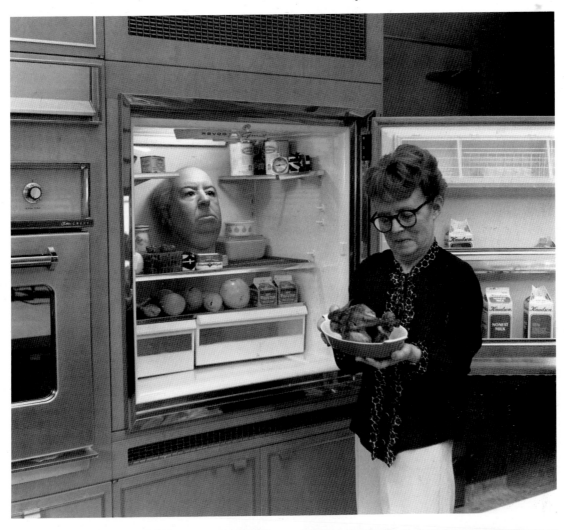

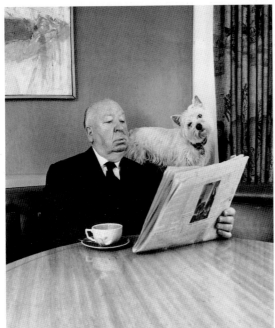

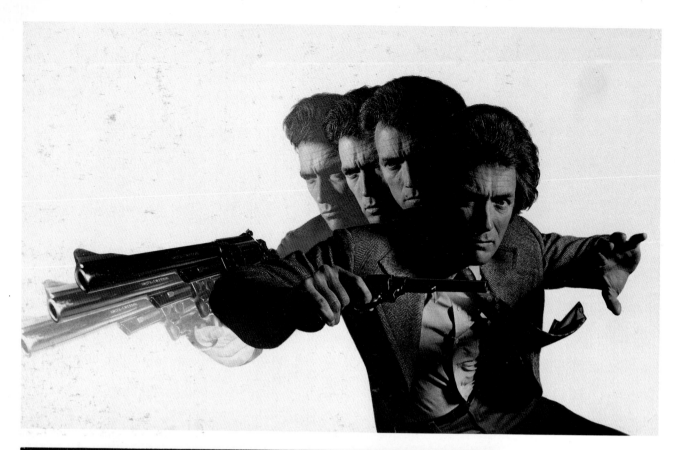

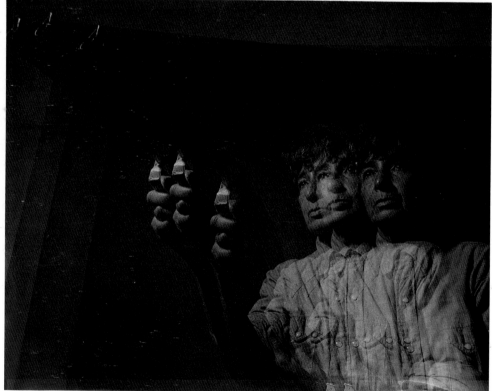

An art director approached Philippe with an interesting assignment. He showed us sketches of Clint Eastwood that he wanted Philippe to translate into photographs for posters to promote Eastwood's movie *Magnum Force.*

Time was short, and the art director warned Philippe that Clint was very impatient with photographers. We did tests late one night with me posing with Philippe's homemade "gun."

When we arrived at the studio in Hollywood, the first thing Philippe did was to show Clint the Polaroid test shots of me that matched the sketches for the posters. Clint was so impressed by Philippe's professionalism that he was friendly and enthusiastic during the several hours he spent with us.

Y.H.

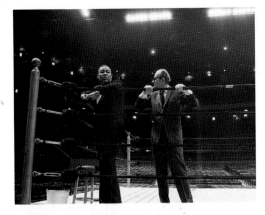 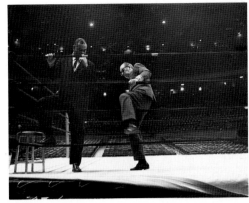

 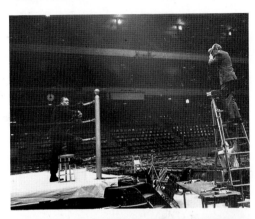

Joe Louis paid a sentimental last visit to Madison Square Garden for *Life* in 1968. Philippe tried several approaches to convey the sad mood.

Y.H.

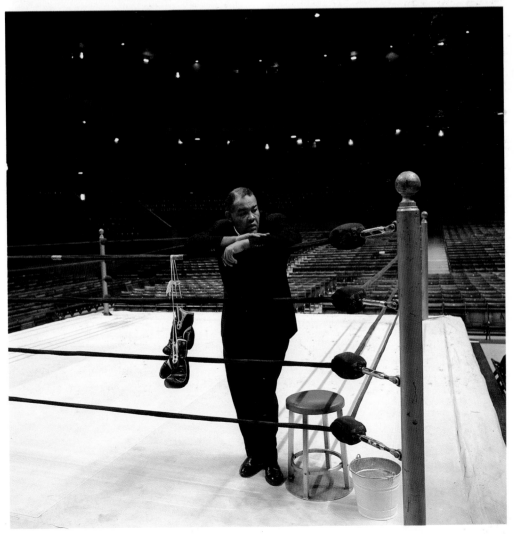

Philippe made many portraits of Vladimir Nabokov that were used for the jacket covers of his books as well as many magazine covers. In 1968 we spent a fantastic week working and talking with this great author and his wife Vera in Montreux, Switzerland. In one shot, Philippe caught in Nabokov's glasses the reflection of the butterflies pictured in the book he was reading (Nabokov was a famous lepidopterist).

Y.H.

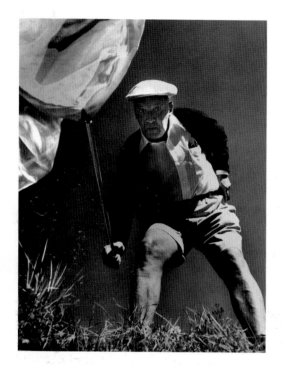

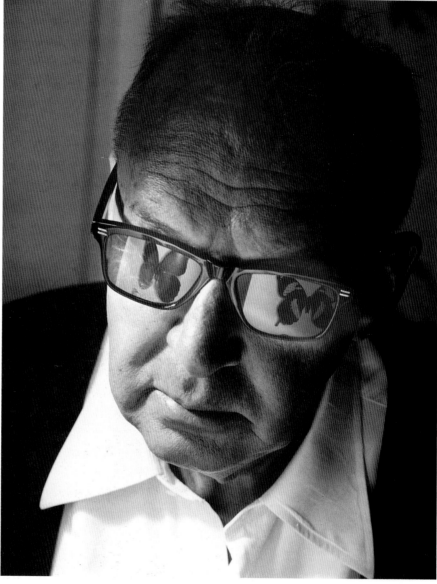

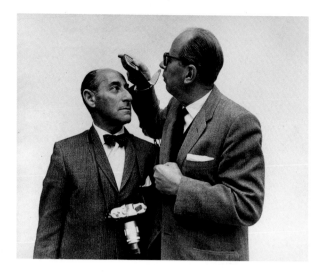

Philippe's colleague Alfred Eisenstaedt was photographed in Paris in 1964 for the Famous Photographers' School. Philippe wrote on the back of the photograph he sent to Eisie: "This photograph expresses my admiration for the agility of Eisie's feet and for the steadiness of his hand (no tripod necessary)."

Y.H.

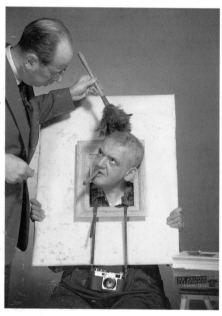

In 1961, after a sitting with Weegee, Philippe and his friend, the famous *Daily News* street photographer, horsed around in our studio.

Y.H.

Philippe often took test shots before a sitting that would require several set-ups. In 1968 I levitated in place of the Maharishi Mahesh Yogi.

Y.H.

"If you give me five more minutes," I addressed the guru, "I will make a picture showing you in levitation."

"You mean, showing me suspended in midair?" he exclaimed and giggled excitedly like a child. "Take all your time."

P.H.

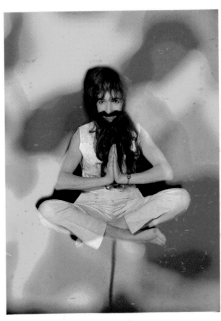

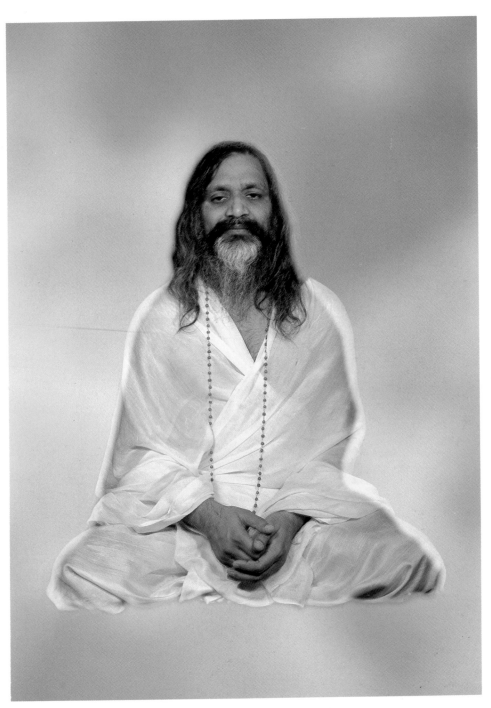

GROUP PORTRAITS

A photograph is not only the solution of a photographic problem, it is also a statement of the photographer about his subject. The deeper the photographer, the deeper his statement. Therefore, in my opinion the photographer should not concentrate solely on the development of his technique. Much more important is his own development as a human being. P.H.

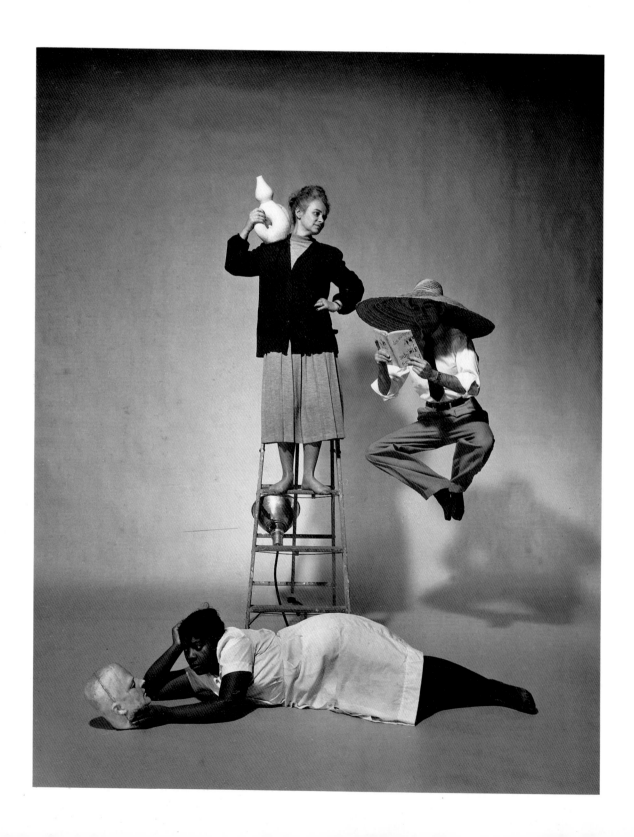

Philippe used his studio assistants in this test shot he made in preparation for the sitting with five choreographers in 1951 (opposite). That morning I was busy developing film in the darkroom and so, to my great disappointment, was not part of this scene that Philippe called "Halsman studio at work."

Y.H.

A few years ago, I had to photograph a group of five famous choreographers for *Life* magazine (below). It is difficult to make an interesting photograph of a group of five people. I asked one of the choreographers to jump, and his figure suspended in midair makes this group less commonplace.

P.H.

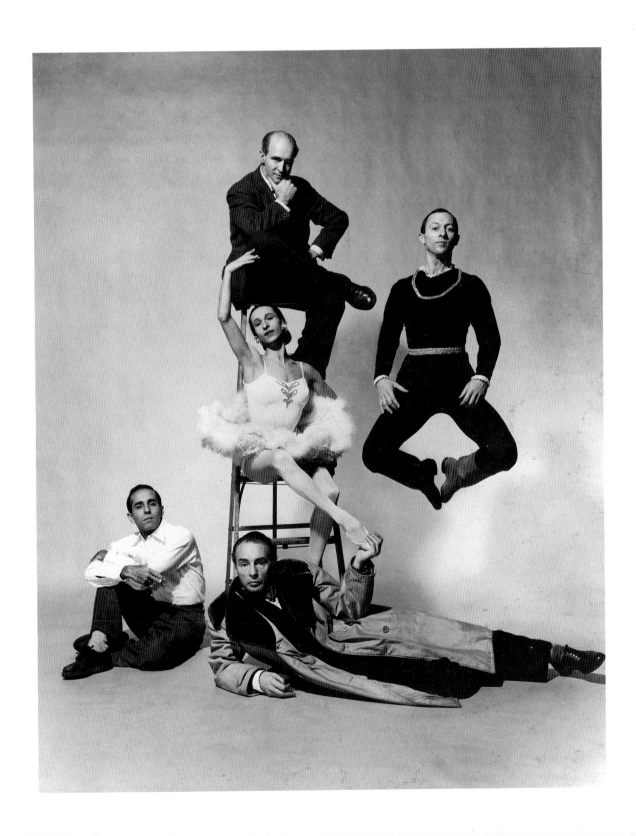

I met Marilyn Monroe for the first time in 1949 when I photographed a group of unknown starlets in Hollywood. She stood out in my memory because she wasted more time in front of the mirror than the other girls. She was never satisfied with her looks—and she never changed in this respect. She could spend hours adding a little lipstick, removing a little mascara, and exasperating the people waiting for her—in this instance me.

Of this group of starlets, only Marilyn emerged. Still photographers discovered her unusual talent for flirting with the camera lens, and her blonde looks of instant availability made her America's most popular pinup girl. Marilyn felt that the lens was not just a glass eye but the symbol for the eyes of millions of men. She knew how to woo this lens better than any actress I ever photographed.

P.H.

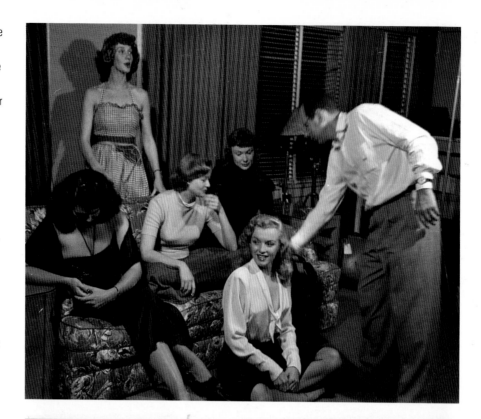

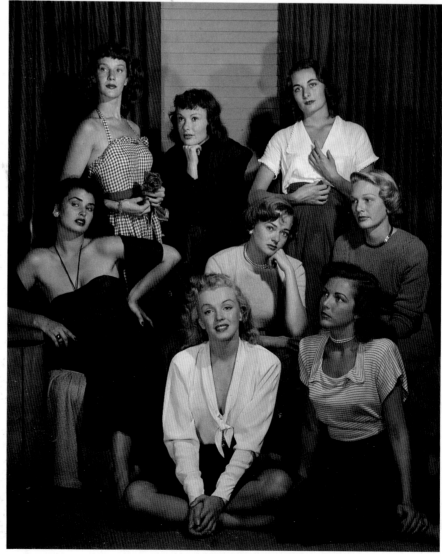

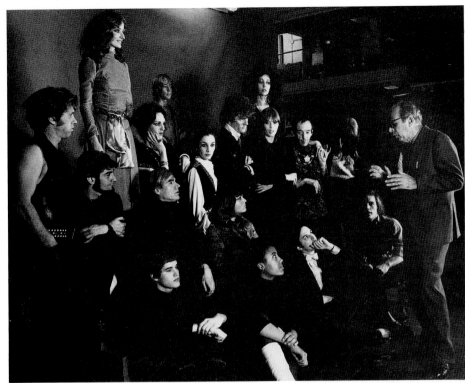

Andy Warhol brought his entourage from the Factory to the large *Life* studio in 1968.

Y.H.

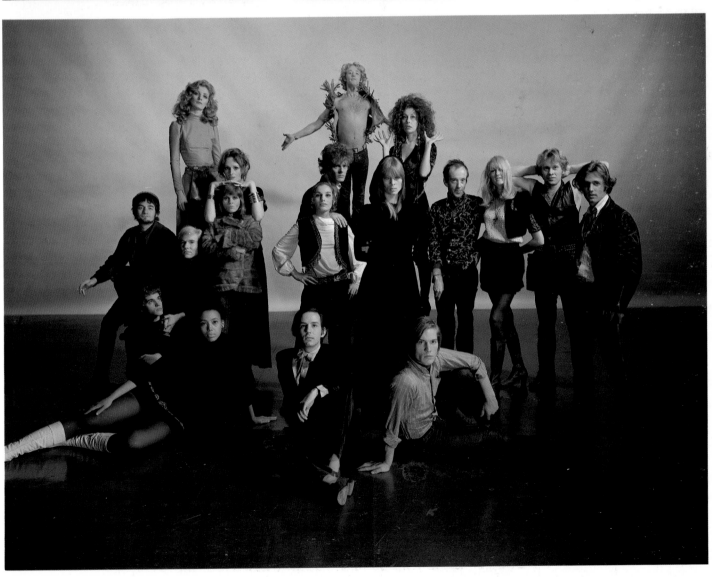

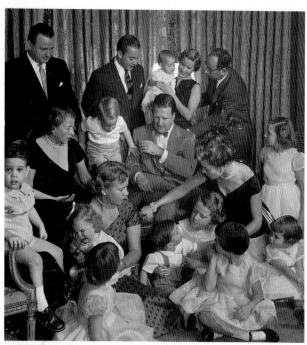

For a magazine assignment in 1952 Philippe was asked to photograph the Ford clan in Detroit. As Philippe said later, it was a harrowing experience to photograph the group. Luckily for me, I wasn't there. An assistant took the picture of Philippe arranging the family members.

Y.H.

Collier's assigned Philippe to photograph the five Eisenhower brothers in 1948, when Ike was president of Columbia University. The brothers posed so stiffly that Philippe asked Ike to tell a joke. It worked!

Y.H.

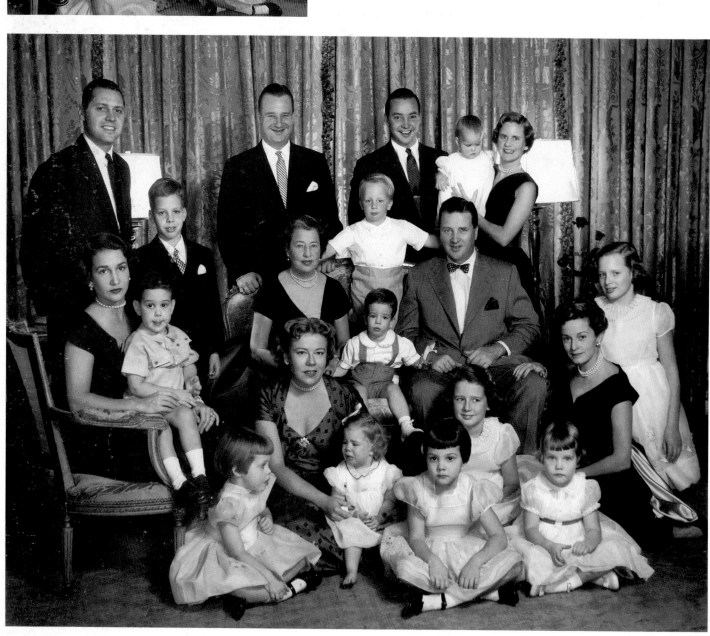

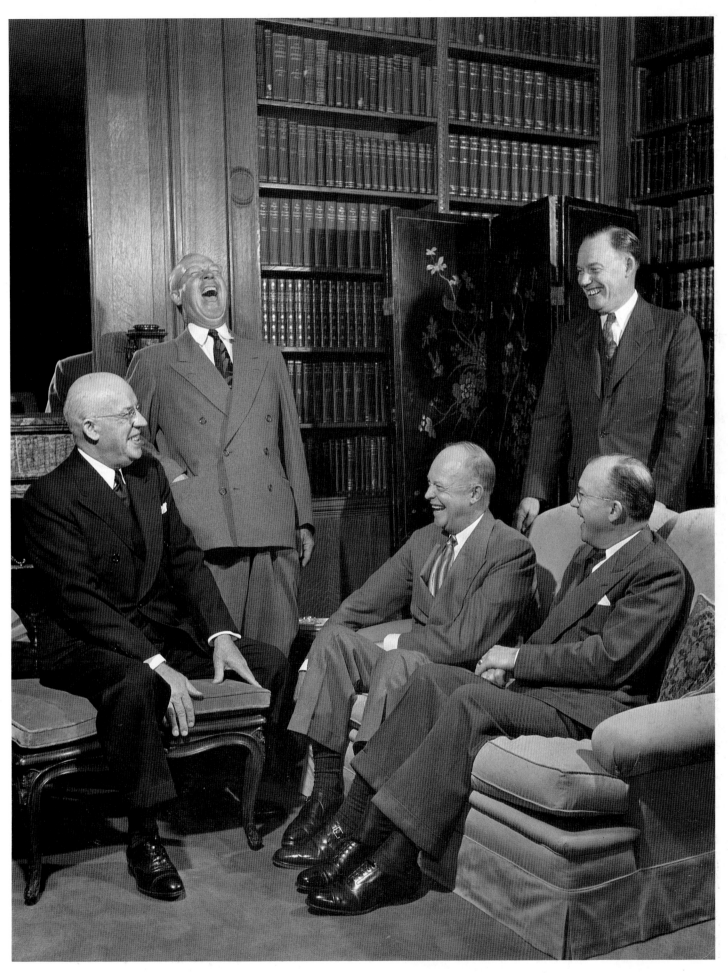

In 1948, Philippe photographed three dancers from the New York City Ballet—Ruth Ann Koesun, Melissa Hayden, and Eric Braun—on the Bridgehampton Beach for *Life*'s "Speaking of Pictures" feature.

Y.H.

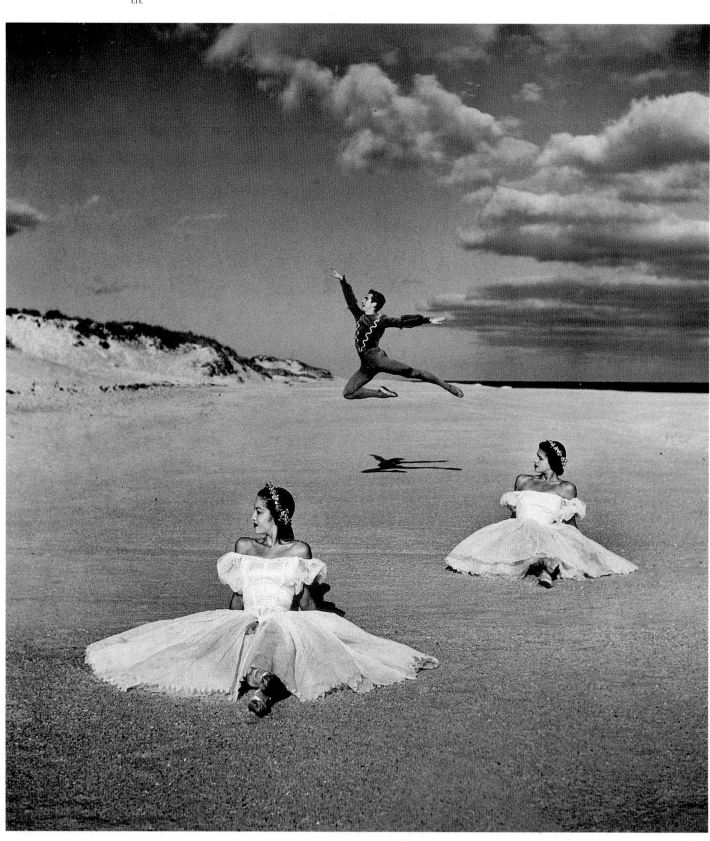

Philippe and a researcher from *Life* magazine pondering their choice of the most photogenic coed at Gulfport College in Mississippi. A three-page spread ran in *Life* in 1950.

Y.H.

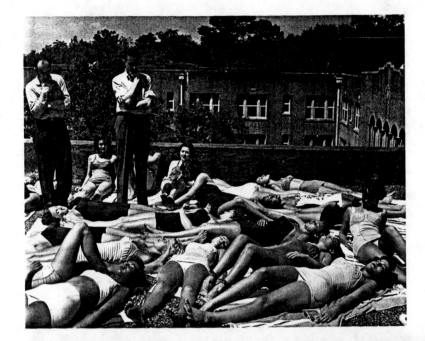

This picture was taken during an assignment for a *Life* summer fashion story shot in Bermuda in the late '40s. Philippe called this picture "the most beautiful bathing suit." Needless to say, it never appeared in the magazine.

Y.H.

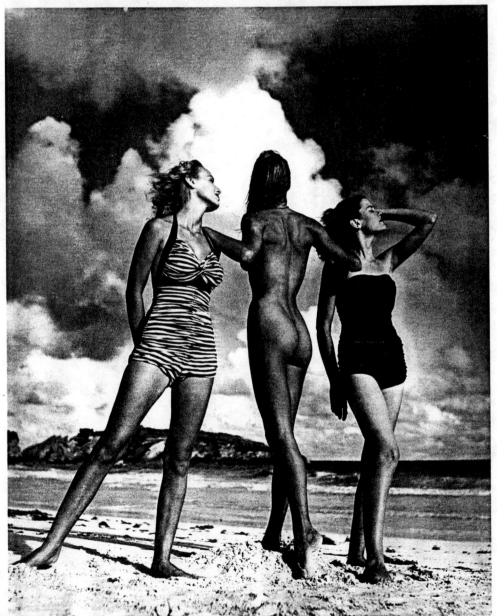

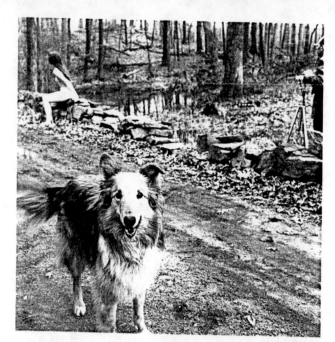

In 1960, the publisher Roger Straus assigned Philippe to take a picture for the cover of the book *The Wayward Wife* by Albert Moravia. Roger asked Philippe, "Do you have any ideas?" Philippe said, "Yes, Roger, I'll photograph a naked girl on a lonely road!" Roger said, "It's a good idea, but where will you find a naked girl?" Philippe answered, "Roger, where will I find a lonely road?"

Philippe had previously shot the cover for Moravia's book *Two Women* in 1958. Now a strange thing happened. For the second time, critics gave a much more flattering review to Philippe's cover than to the content of the book. Moravia's reaction was to tell his publisher not to use Philippe anymore for his book jackets!

Y.H.

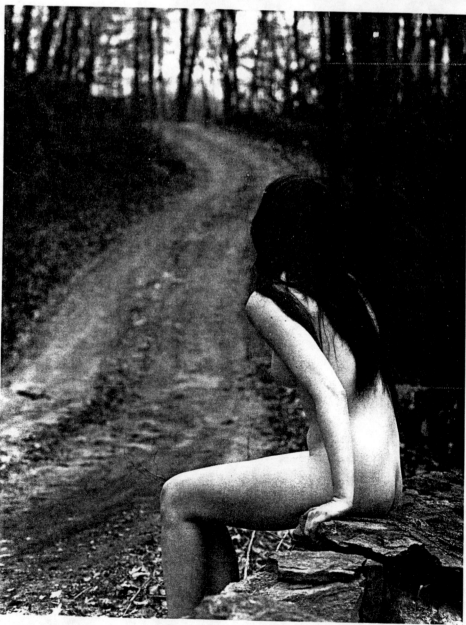

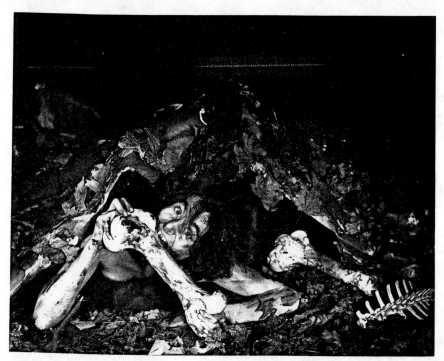

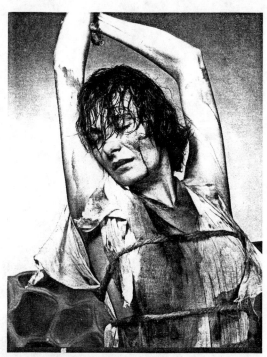

Philippe discovered Ricki Soma in 1947 in the corps de ballet while he was doing a story for *Life* on City Center ballet dancers. He was struck by her beautiful Italian face that reminded him of the Mona Lisa. On the strength of her beauty, *Life*'s editor put the portrait of this unknown girl on the cover.

Upon seeing the cover on the newsstand the very day it appeared, Hollywood producer Jesse Lasky hopped on a plane for New York to bring Ricki back to California with a movie contract. For two years she had only a few small parts.

One day she came back to New York and asked Philippe to take some interesting pictures of her to submit for a possible role.

Philippe had the idea for a series he called "Ricki Through the Ages," in which Ricki was portrayed as different women in history. The series began with a cave woman. A Greek goddess, a Christian martyr, a Renaissance madonna, an aristocrat of the ancien régime, a French courtesan of the Empire period, and a modern woman in a Christian Dior dress followed. The final photograph in the series showed Ricki back in her cave after World War III (Phillipe was a pessimist at heart).

When she returned to Hollywood, Ricki took these pictures to John Huston. She told us later that these images were magic. He was impressed by her beauty, and that seductive Dior dress prompted him to ask her to dinner that same night.

A few months later they were married.

Y.H.

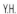

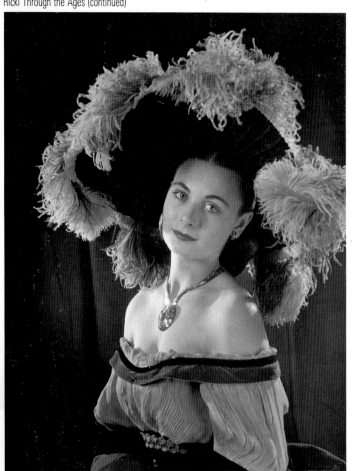

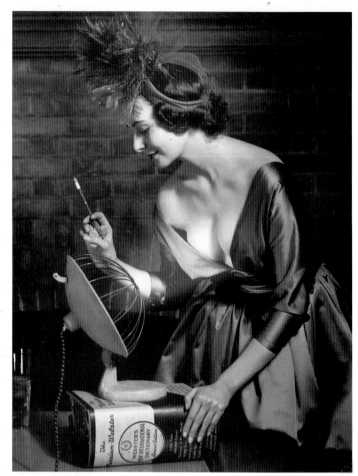

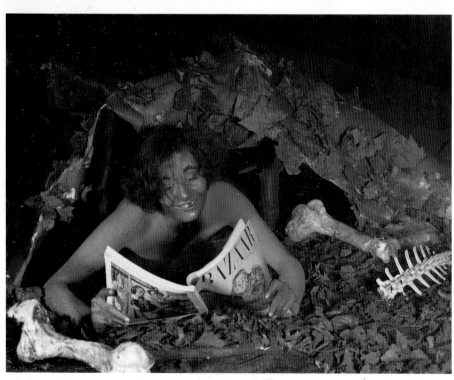

In 1956 I was asked by *Life* to make a trip around the globe and to select the most beautiful girls of the world. The trip covered sixteen countries and 60,000 miles. I was not only the photographer but also the supreme beauty judge, and I had to search for the beauties and for significant backgrounds to pose them against. Because of time pressure, it became probably my most exhausting assignment. It led me to Bali and Vietnam, to Japan and Brazil, to Sweden, West Africa, and India. After appearing in *Life* my photograph of the Israeli girl resulted in her marriage to an American. The photograph of the Italian beauty, Rosana Schiaffino, whom I discovered, made her a movie star.

P.H.

I went along as Phillipe's assistant. We had 300 pounds of equipment more than the airline would allow, since *Life* at that time did not accept 35mm color films for portraits and Phillipe had to bring all of his large format cameras.

Y.H.

West Africa

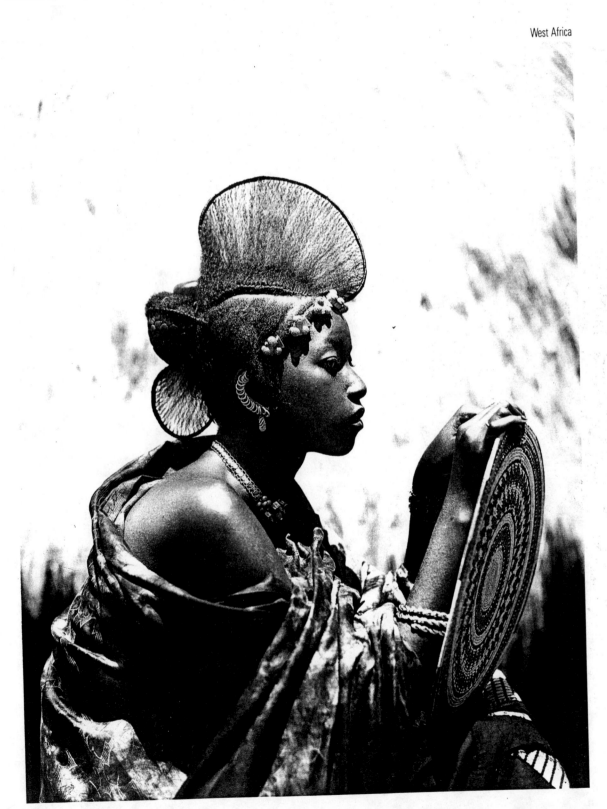

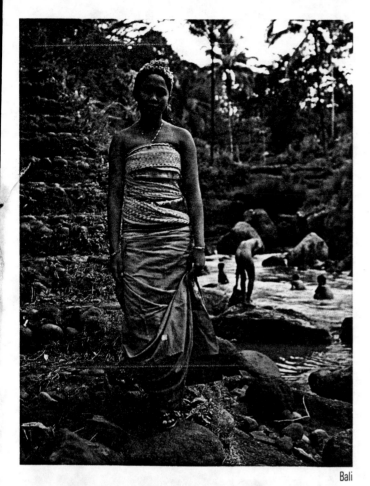

Bali

Italy

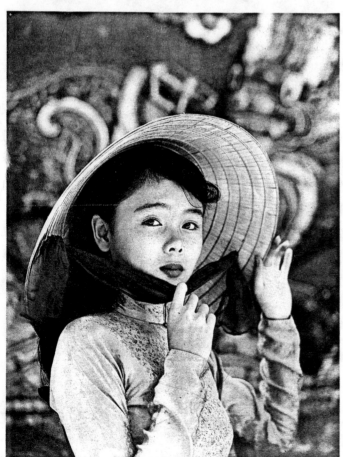

Viet Nam

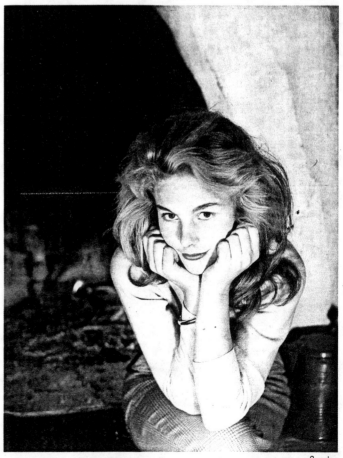

Sweden

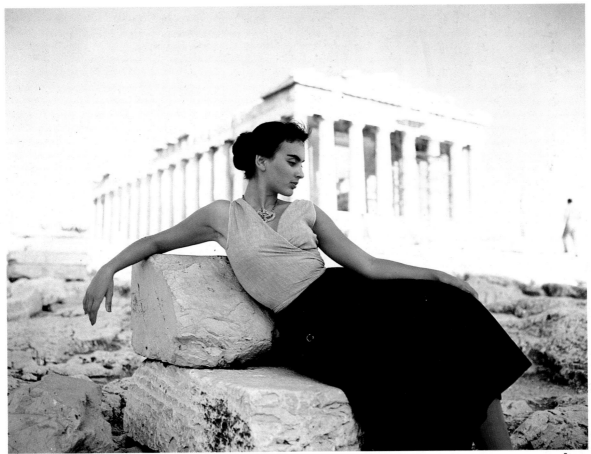

Greece

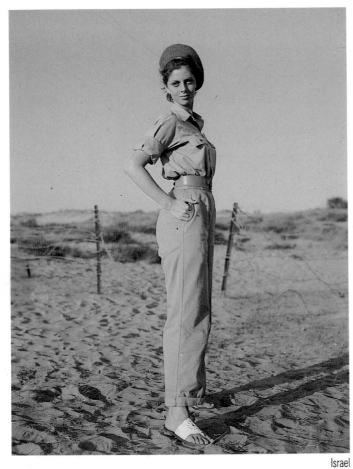

Israel

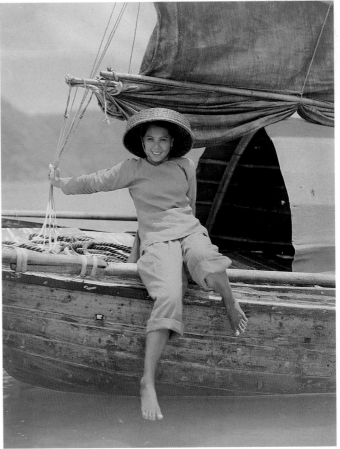

Hong Kong

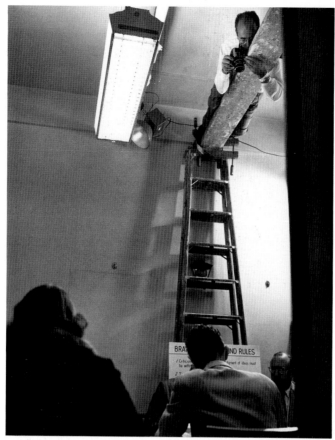

This picture of one of their brain-storming sessions was taken for a BBD&O annual report in the late '50s. The room was too small for Philippe to photograph from the floor so he had the idea to shoot from above and asked for two ladders and a board.

Y.H.

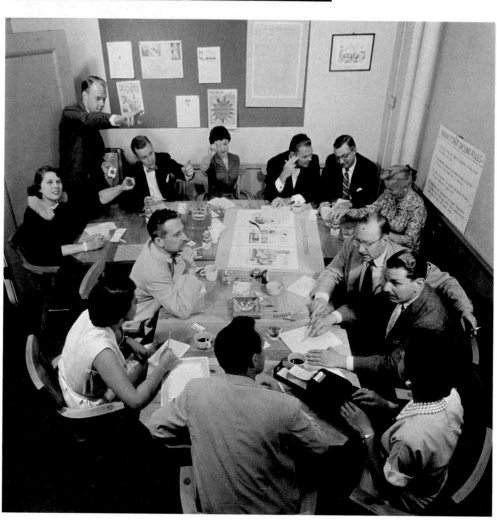

All the pictures Philippe took for an annual report for a dress designer were so far out that they were deemed "unacceptable." I modeled for the test (left). The model for the actual photographs (below) was Veronica Hamel, who later gained fame as Joyce Davenport in "Hill Street Blues."

Y.H.

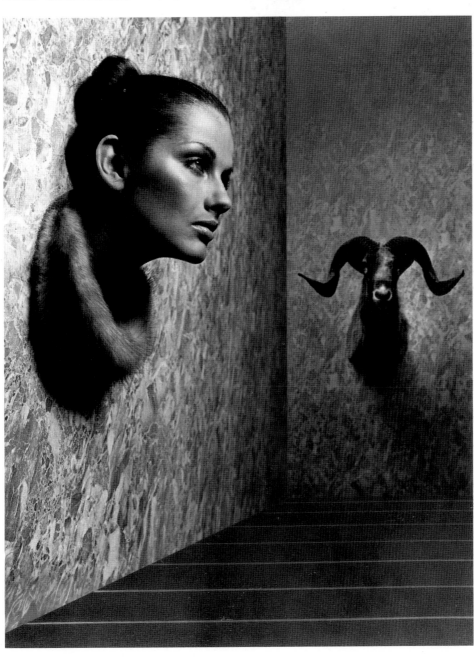

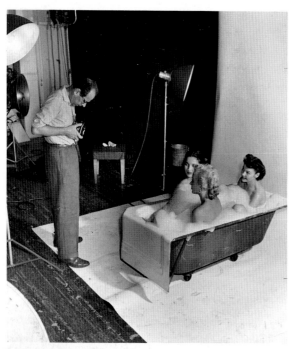

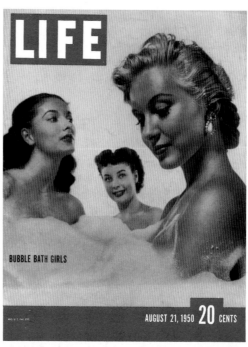

This photograph was taken in the studio for a *Life* cover in the summer of 1950. The three showgirls were from the cast of *Peep Show*, a hit Broadway musical produced by Mike Todd.

On stage, Todd had thirty showgirls poke their heads through holes in a canvas into a bubble bath. This specially built set cost $36,000—at that time an extravagant amount of money.

Y.H.

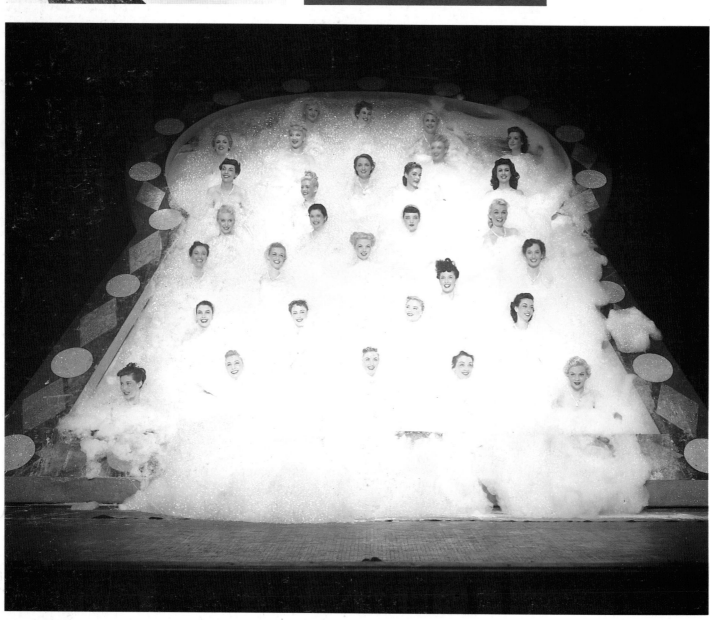

I was on assignment for *Life* to shoot an international meet of underwater ballet swimmers. For three days I photographed the girls doing the most complicated wheels and tricks under water. Once, during a break, the winning Canadian team came to the surface to gulp for air. From the bottom of the pool I photographed them treading water. This artless feat was given the place of honor in print. The impact of the missing feature—a dozen girls without heads—was too powerful. Or was it because the editors had finally found their image of the ideal woman, all body and no head? P.H.

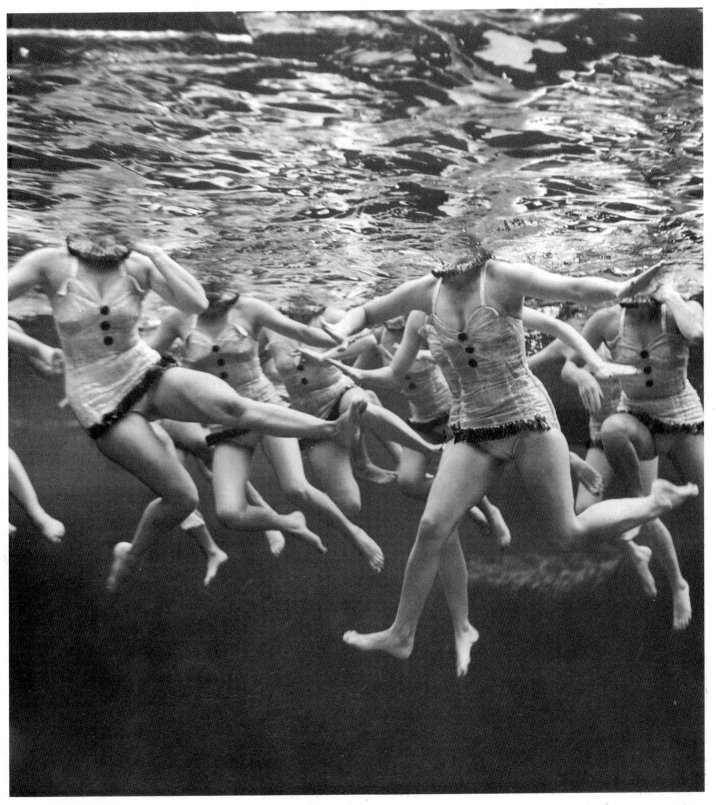

EXPERIMENTS

Many of my friends think that I damage my reputation as a serious photographer by publishing experimental and surrealistic photos like the ones I did with Dalí and others. I believe they are wrong. Photography is an unusual means of expression because it straddles two art forms. It not only attempts to give us a visual impression of reality the way painting and the graphic arts do, but it also tries to communicate and to inform us the way the written word does. No writer is blamed for writing about things that exist only in his imagination. No photographer should be blamed when, instead of capturing reality, he tries to show things he has seen only in his imagination. Photography is the youngest art form. All attempts to enlarge its frontiers are important and should be encouraged.

P.H.

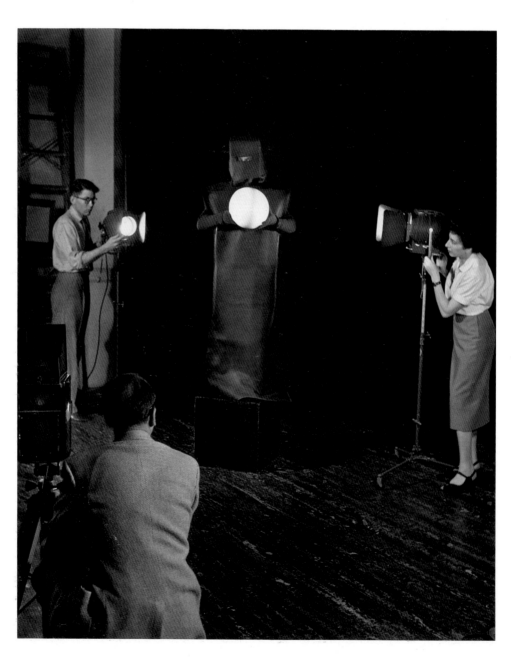

Dalí had always been tormented by Picasso's fame. After seeing the photograph by Gjon Mili of Picasso drawing a bull in the air with a small flashlight, Dalí confided to Philippe: "You know, I can do much better. I'll make a sculpture in complete darkness."

Philippe was easily persuaded but had to conceive a suitable solution to this difficult photographic problem.

Dalí was dressed in black from head to foot. Philippe made a small slit for the eyes in the hood. Dalí held a white porcelain globe; he also had a long white porcelain tube. In total darkness he proceeded to slowly move the arm that held the globe, starting with the head. Then he took the long tube to make the neck and arms. We followed his movements, lighting up only the sphere or the tube with two spotlight beams. Philippe used the 4 x 5" camera and left the lens open during this procedure.

Y.H.

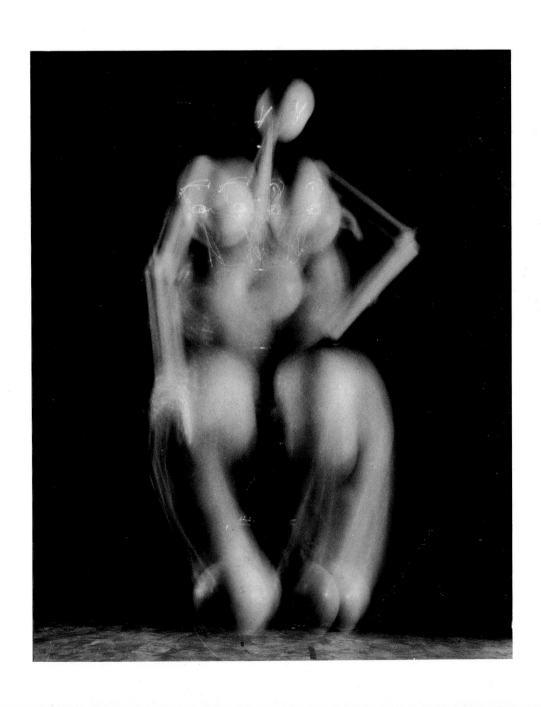

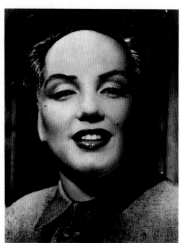

In 1967, during one of his extended visits to New York, Dalí asked Philippe if he could think of a way to make Marilyn Monroe look like Chairman Mao. Philippe was stimulated by the challenge, and he carefully scaled one of his famous portraits of Marilyn with a close-up of the Chinese leader.

Y.H.

Once after a portrait sitting, a glamorous Hollywood star left her paraphernalia in my studio: a couple of false eyelashes, a wig, and, naturally, a pair of falsies. This gave me an idea. I phoned my dentist and asked him to lend me some false teeth. I combined everything into an image that I called "Hollywood Glamour," and photographed it. When I showed the result to my brother-in-law, who like every Frenchman is a great connoisseur of women, he remarked, "You know, she has a certain charm."

The only one who was outraged by this photograph was Dr. Ordman, my dentist. "Do you know what you have done?" he asked. "She has her lowers in the place of her uppers."

P.H.

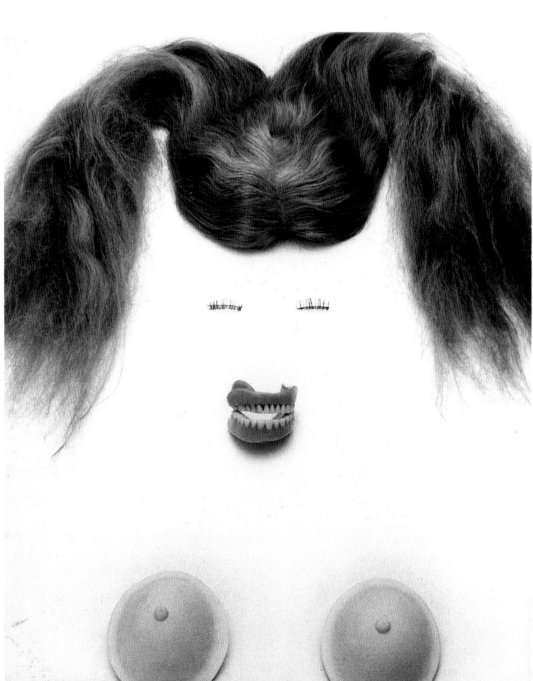

In 1969, Philippe did a story for *Horizon* magazine on a major exhibit at the Museum of Modern Art entitled "Fun Art." He was struck by the spirit of the show, and he created this image by projecting a painting from the exhibit onto the figure of a nude model. He called this photograph "Salute to Op Art."

Y.H.

Philippe used the same technique here, projecting a masterpiece of the Dutch School onto the front of the same model.

Y.H.

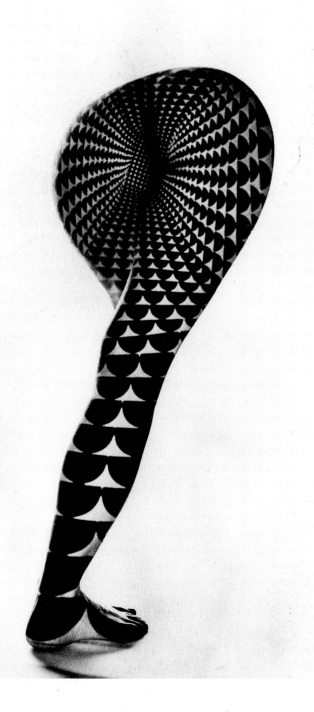

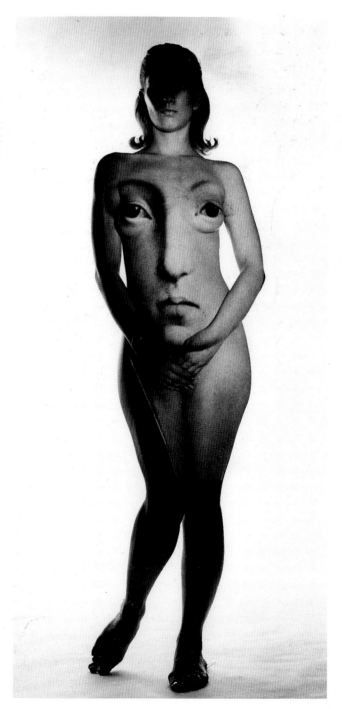

67

Philippe's long collaboration with Dalí produced many memorable photographs. This time, in 1953, it was Philippe's own idea: to make Dalí's face explode. A very awkward problem indeed, but Philippe found a solution and asked me to record the elaborate session. His plan was to project one of his portraits of Dalí onto a pan of milk. (Philippe used to say that milk had just the right viscosity for this particular shot.)

He brought the enlarger down to the studio, mounted the electronic flash inside the head of the enlarger instead of the regular bulb, and placed the negative of a Dalí portrait in the enlarger's film holder. He then synchronized his 4 x 5" view camera to the enlarger with the electronic flash and focused Dalí's image onto the milk. Philippe counted to three. At three, the assistant threw pebbles into the pan and Philippe re-

leased the shutter. It was really catch as catch can, and Philippe made several shots like this.

The end results were quite amazing: Some figures, curiously, resembled a Dalí painting. (Note: Dalí was quite upset at the idea of himself exploding and did not want to see these pictures for several years. Later on he did accept them.)

Y.H.

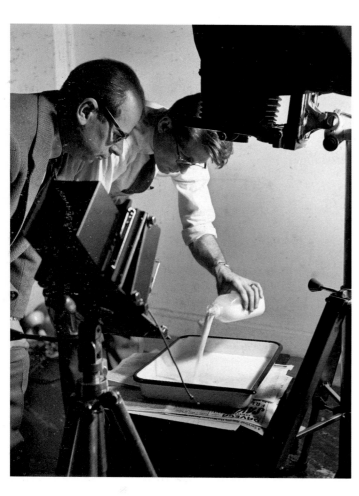

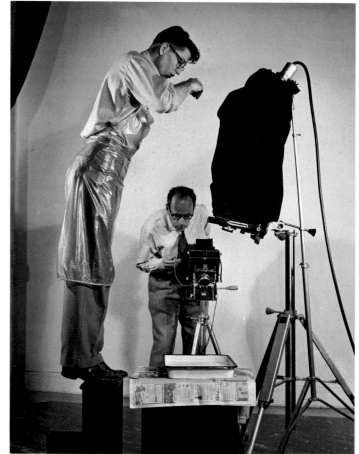

In 1955 we went to Chagall's villa in St. Paul de Vence to photograph the artist in his studio (opposite). After the sitting Chagall took out a painting and suggested going into the garden. He explained that when his work blended well with nature, it was like a thermometer of truth. Then he knew he had produced a work of art. Y.H.

I brought my photographs to Chagall's very beautiful home and put them on the table. The first reaction was favorable. Chagall's wife Bella assured me that she had never seen her husband more profound, and important looking. The painter himself seemed to be greatly flattered and pleased. Suddenly, however, Bella remarked, "Marc, do you think that these pictures are good for the public? Do they look sufficiently Chagallian?" P.H.

Georgia O'Keeffe was photographed in 1948 in her garden at Ghost Ranch in Abiquiu, New Mexico. This photograph has never before been published. Y.H.

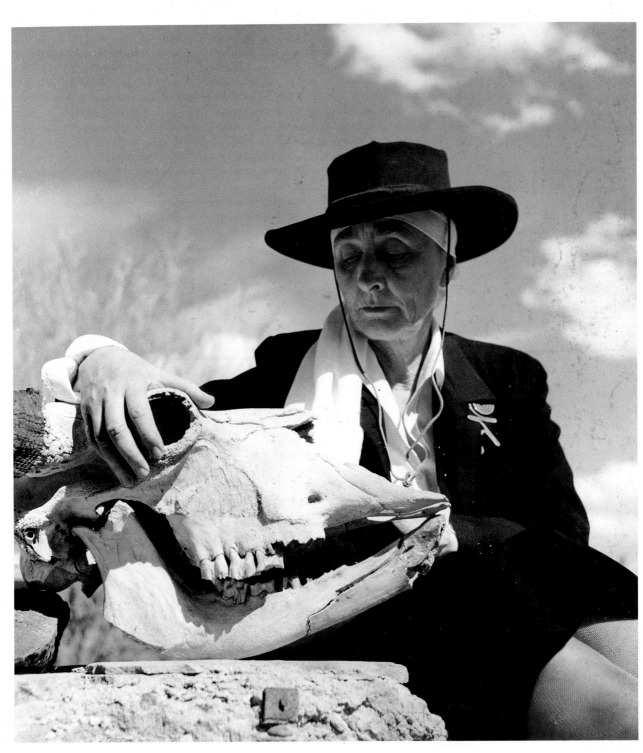

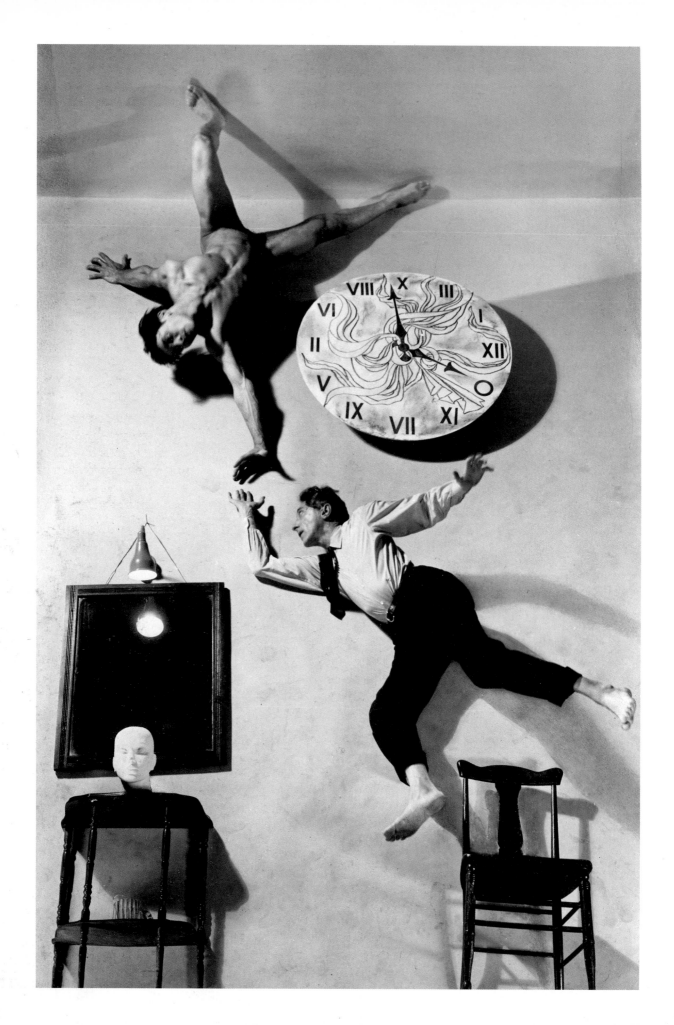

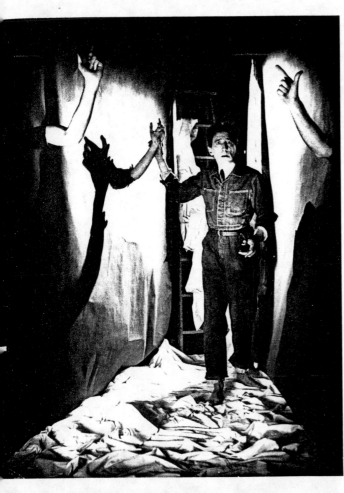

The famous French avant-garde artist and poet Jean Cocteau arrived in New York to present his film, *The Eagle Has Two Heads,* which he had written, designed, and directed. *Life* asked Cocteau whether he could find a day to be photographed in my studio. "A day—no, but a night—yes," answered the poet.

For the sitting with Cocteau I assembled the following elements: a nude model, a live boa constrictor, a girl with a classically beautiful face (Ricki Soma, who later became Mrs. John Huston), a dancer (Leo Coleman, who played a main part in Menotti's *Medium* and was the rave of New York), and a dozen trained doves. I called up Cocteau and asked him whether there was something else he wanted to use. "Yes," he said, "a man without skin." "Are you serious?" I asked incredulously. Cocteau explained that he wanted a plastic anatomical model of a man whose inner organs could be studied by stripping off the outer layers.

In the evening my studio was full of props, models, and a few *Life* editors. Cocteau arrived half an hour late, surrounded by a court of three young male admirers. The admirers climbed on the sill of my studio window and remained there for the rest of the night.

Cocteau turned toward me. He looked aristocratic, sophisticated, and haughty. I was full of expectation: I was sure that with the elements on hand Cocteau's genius would create the most incredible images. "Where is the man without the skin?" he asked. Then Cocteau lay down near the anatomical model, closed his eyes, and said, "Take a picture." When I finished taking this photograph, which was meaningless to me, Cocteau asked, "What do you want me to do next?"

To my immense disappointment I saw that instead of my becoming the instrument of his imagination he was ready to be the instrument of mine. It proved again that even people who are supposed to be fountains of imagina-

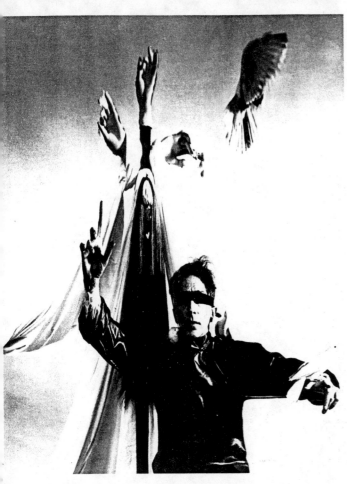

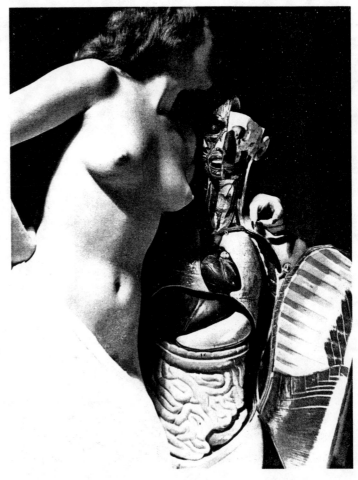

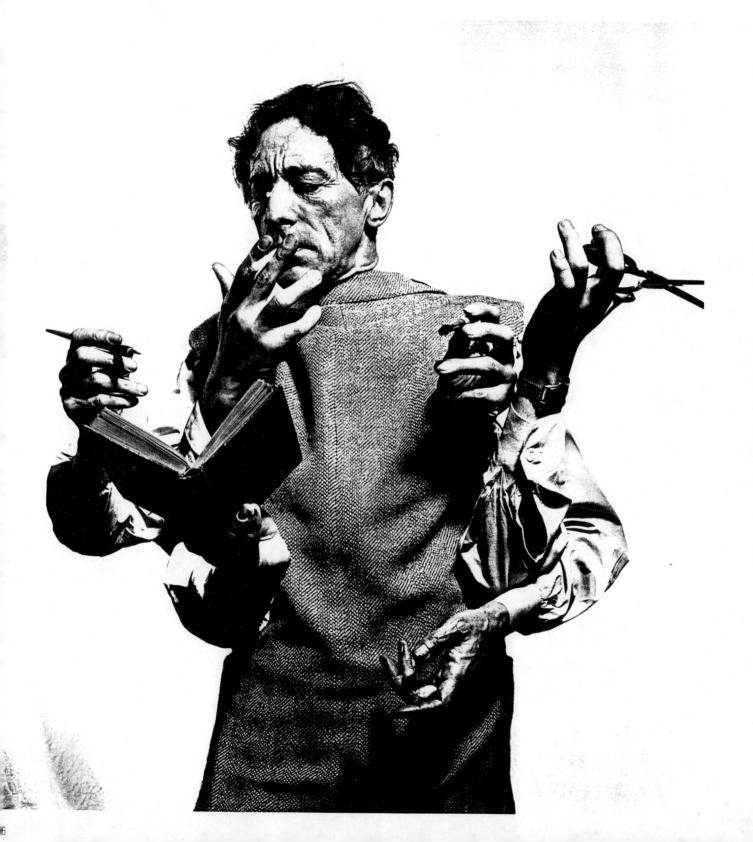

tion cannot spurt on too short a notice. Fortunately I had spent many hours pondering about what I could do with my props. I described the pictures I had in mind to Cocteau, who listened with apparent contemptuousness. He executed my suggestions, however, with amazing flair and acting talent. First I photographed him against a black background, which gave me the possibility of later sandwiching the negatives in order to get multiple images. Then we used and got rid of the boa constrictor and the doves, whose training unfortunately did not include droppings control. Then the model took off her dress, revealing a classically perfect body. I covered her with a wet sheet and Cocteau pretended to mold her, bringing life to a piece of white clay.

I asked Leo Coleman to undress, and when his magnificently muscled body appeared, a murmur of admiration came from the group of Cocteau's friends. For Cocteau, it was a *coup de foudre*. I have never seen a man court a woman with the exquisite elegance and style that Cocteau displayed toward the young man. He worried about Coleman catching cold and with touching solicitude draped his own scarf around the dancer's neck.

I made a photograph showing the two floating in a room. Then I put a picture frame around the beautiful face of the future Mrs. Huston, gave Cocteau a brush, and asked him to pretend that he was painting her. The frame was still in my hands when I realized that I did not know by what means it should be supported. For a while everybody was stumped till I got the idea of asking Coleman to lie down and brace the frame against his side. In the meantime Cocteau's haughtiness had gradually diminished. After hearing my last suggestion he started to call me

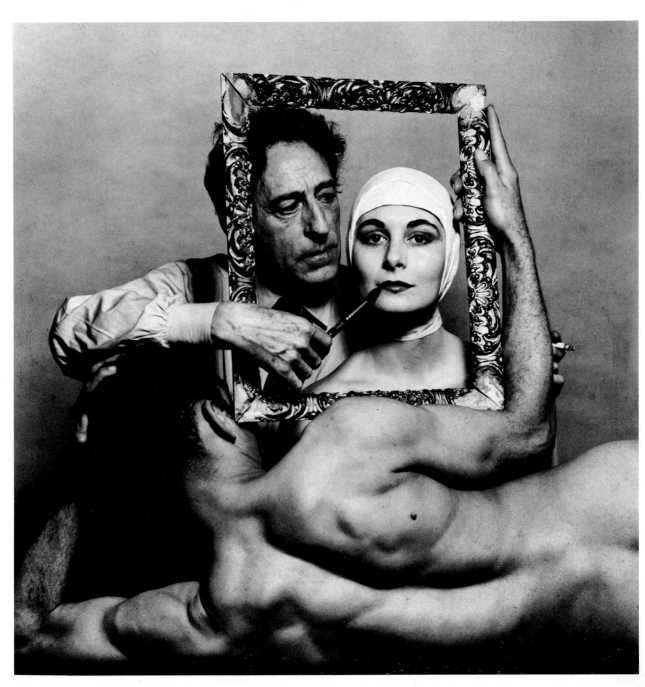

77

by my first name and to address me with the comradely "tu," making it sound as if I were getting a promotion.

Finally I wanted to show a drawing coming to life. Cocteau drew two figures on a huge white sheet of paper under which I placed the nude model and Coleman. We cut holes in the paper to make it appear as if parts of the drawing had become alive and real. Later *Life* wanted to include this picture in its story on Cocteau, but the editors thought it too daring because the model's nipple was showing. "We could print it," one editor pleaded, "if you let us remove this point!" "But then the photograph will have no point," I replied, full of artistic integrity. The times have, however, changed. This photograph, which lay unpublished in my files for twenty years, is today on the book jacket of Francis Steegmuller's biography of Cocteau.

The sitting ended early in the morning. Before leaving, Cocteau asked my wife Yvonne to take a photograph of me photographing him quietly sitting on a chair. When later *Life* editors interviewed him about the symbolic meaning of each photograph, Cocteau replied, "You better ask the camera. All I did was sit in front of the lens."

Of all the pictures, Cocteau liked most his Januslike double profile, possibly because it expressed the title of his film *The Eagle Has Two Heads*.

Several years later a Frenchman showed me Cocteau's new signature. "Have you ever seen anything more original?" he asked. I saw that the great artist had paid the ultimate compliment to a photographer. He had begun to draw under his signature the double profile that I had produced by sandwiching two negatives.

P.H.

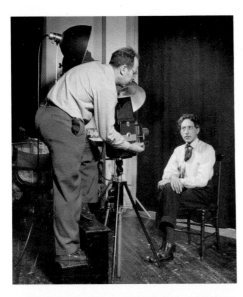

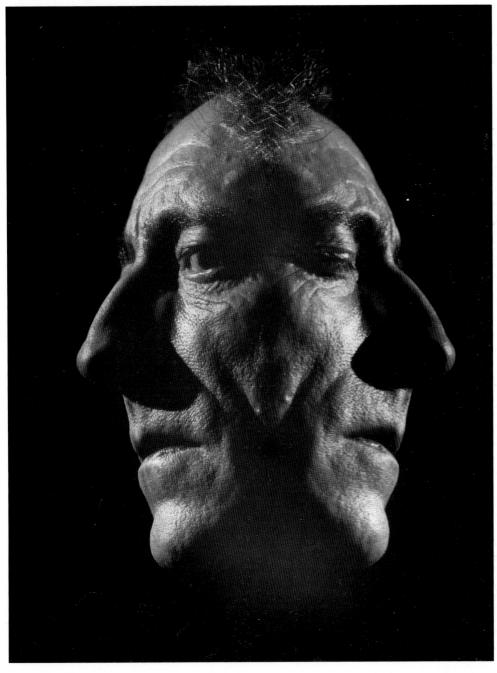

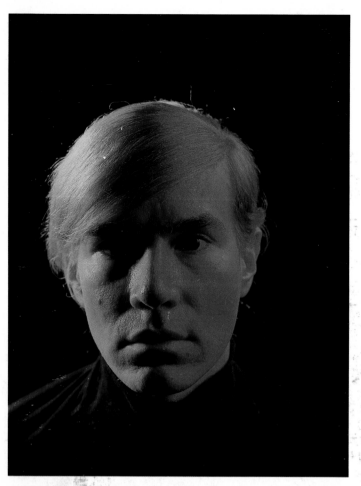 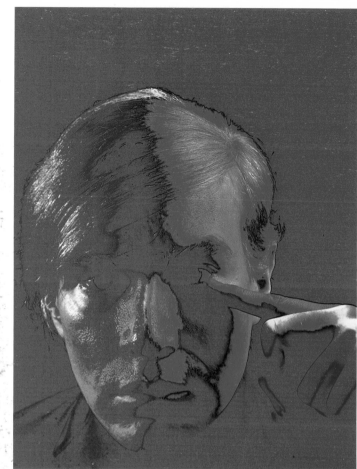

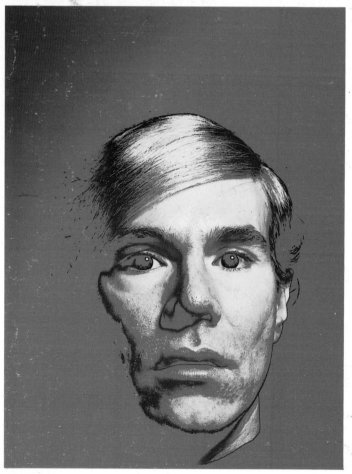 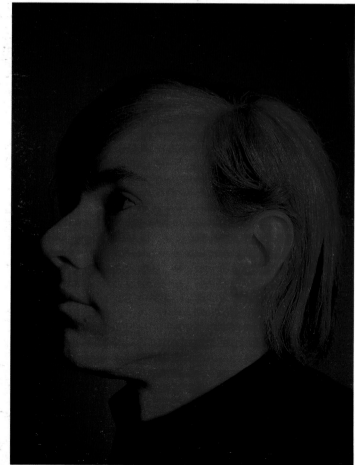

Philippe took these portraits of Warhol in our studio using color gelatins over the electronic lamps. He also decided to solarize some of them in the *Life* lab. The double exposure shows a concentrated Andy Warhol.

Y.H.

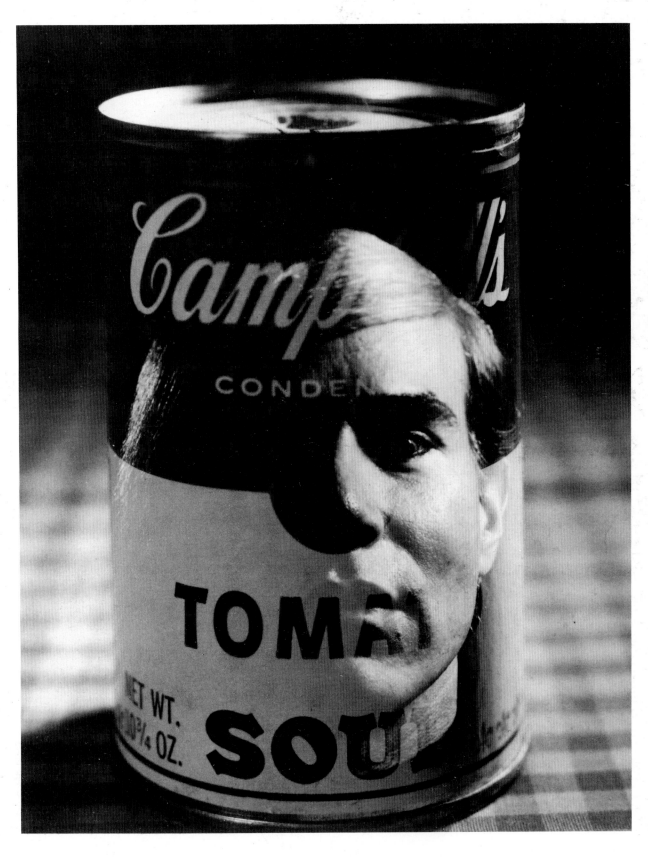

DALI

Why does Dalí pose for such photographs? Although too intelligent to disregard the power of publicity, the question whether my pictures will appear in a magazine does not preoccupy him. As a matter of fact, most of my Dalí photographs have never been published. The real reason is that Dalí is a Surrealist *à outrance*, not only in his painting, but in every respect. He wants to startle and to shock with the sum total of his actions. The pressure of his creativity finds only a partial outlet in his art. Dalí has made himself the most Surrealistic of his creations, in his looks, his dress, his behavior. Even his handwriting and his spelling are more Surrealistic than most of his paintings.

Dali likes to be photographed by me because he is interested in photographs that don't merely record reality. In photographs too he wants to be shown above reality, that is, Surrealistically. But there is another reason. Dalí has a deep-seated need of being the center of attention, a need that devoured him already in childhood. Whenever I need a striking or famous protagonist for one of my wild ideas, Dalí graciously obliges. Whenever Dalí thinks of a photograph so strange that it seems impossible to produce, I try to find the solution.

P.H.

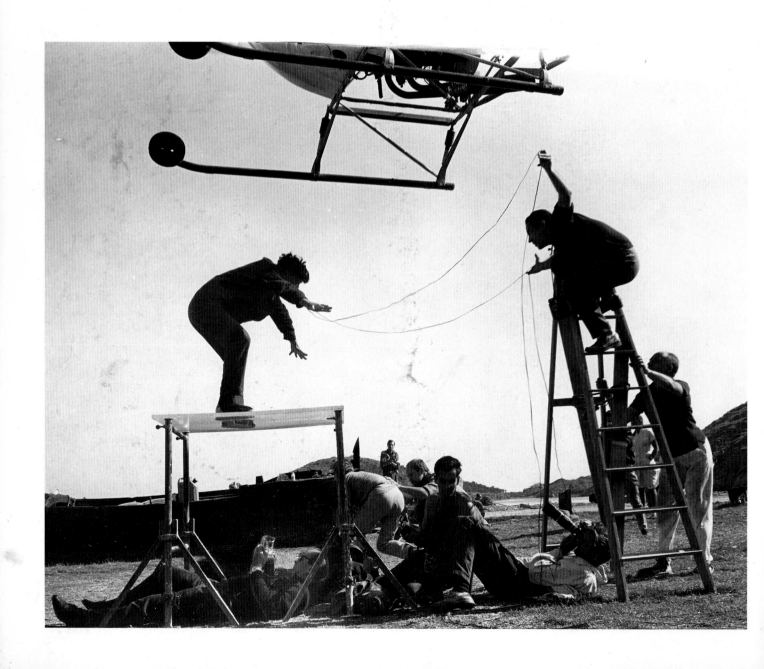

In 1964, when the radio and news-papers announced that Dalí had shaved his mustache, we were stunned! We rushed to Port Lligat, Dalí's home. We couldn't bear the thought of Dalí without his mustache and we had to see his new face. Fortunately, the information was wrong, and Philippe and Dalí concocted a photograph to show the world that Dalí's mustache was still there, as strong as ever.

Here I am divulging the secret of how the photograph was made.

Y.H.

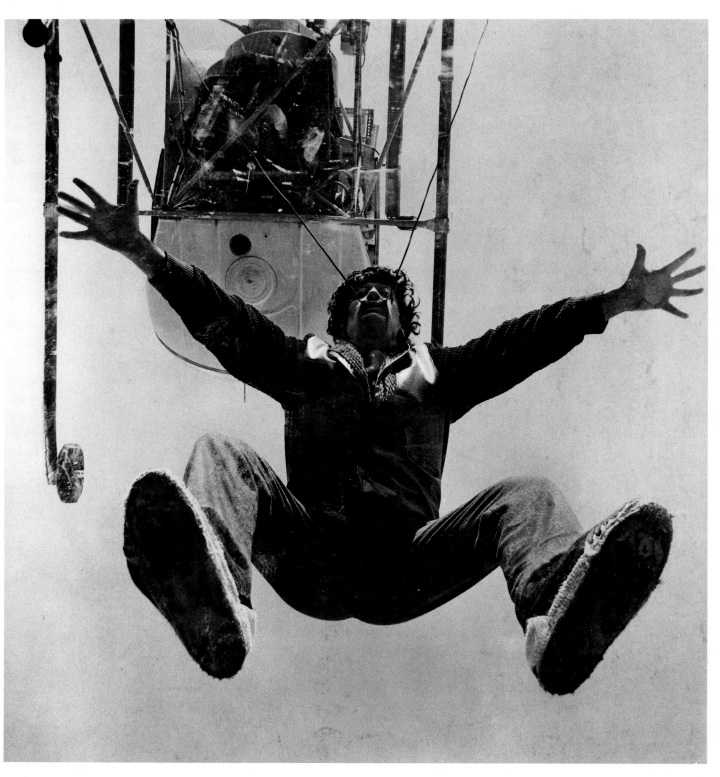

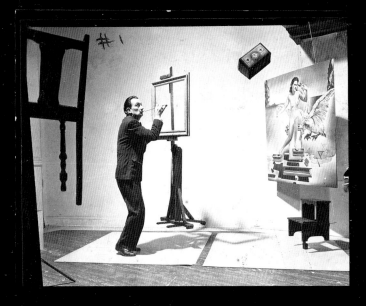

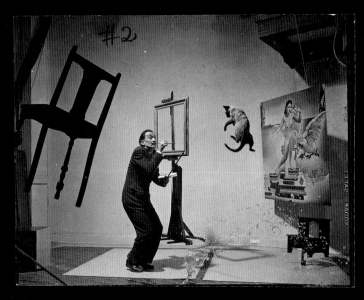

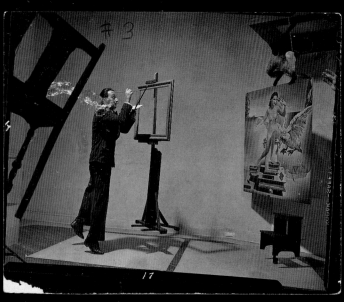

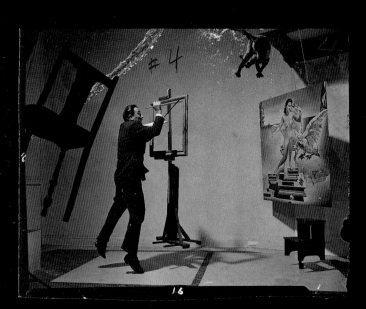

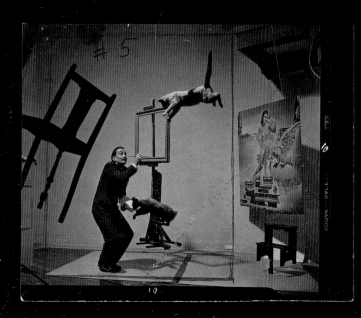

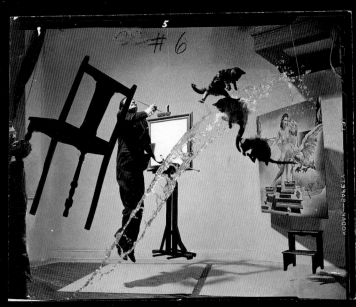

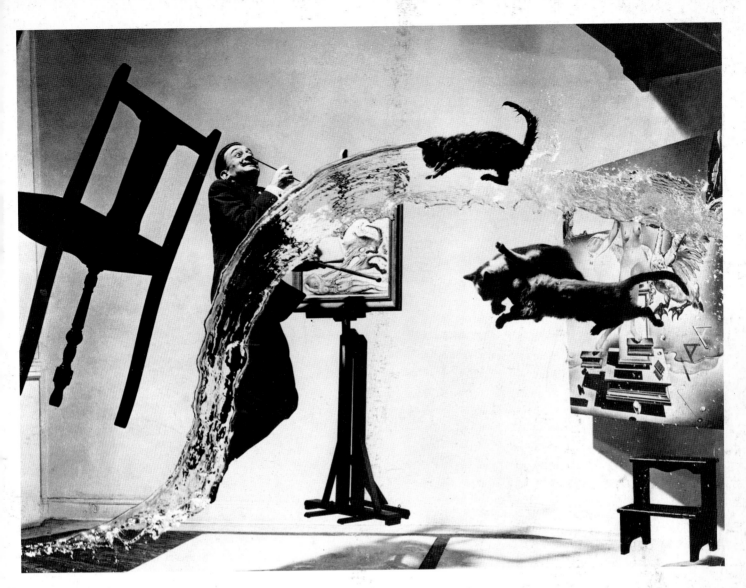

In 1948 Dalí had an exhibit in which the most important painting was called *Leda Atomica*. It represented the naked Mrs. Dalí as Leda and showed her being embraced by the swan. Everything in this painting seemed to be suspended in midair: Mrs. Dalí was not sitting but floating over a pedestal, the swan was not touching her and even the wave breaking against the pedestal seemed not to have any contact with the bottom of the sea.

"Dalí," I asked, "why do you call it *Leda Atomica*?"

"Because in an atom everything is in suspension—the electrons, protons, neutrons, and other junk," answered Dalí, "and since I live in an atomic era I have to paint everything suspended in space."

The next morning I phoned Dalí: "I have an idea for a photograph called *Dalí Atomicus*. In it, you, the easel, and the subject you are painting and which is already pictured on the canvas—in short, everything—are in suspension. I know exactly how the photograph should look, but I don't know what the subject of your painting should be. I thought you would like to decide it yourself."

"I like your idea," said Dalí. "Come over to the St. Regis and let's discuss it."

At the hotel Dalí greeted me excitedly: "I know what the picture should be. We take a duck and put some dynamite in its derriere. When the duck explodes, I jump and you take the picture."

"Dalí, you forget that we are in America. We will be put in prison if we start exploding ducks."

"You are right," Dalí said. "Let's take some cats and splash them with water."

In my studio I suspended an easel and a few other objects with invisible wires and hung a large photograph of *Leda Atomica* from the ceiling. I had two assistants on the right of my camera and two on the left. Three of them were each holding a cat in his hands, the fourth one a bucket filled with water. Yvonne was holding the chair. I counted aloud to four. At "three" the assistants threw the cats and the water, and while the cats and the water were still sailing through the air, Dalí jumped at "four." At the height of Dalí's jump, I released the shutter, and

my electronic lamps froze the entire scene. Then, with the exposed film I ran into my darkroom, developed the negative, and scrutinized its composition. Hurriedly I returned to the studio and announced, "The composition is imperfect. Let's start again." The assistants wiped the water off the floor, caught the cats, and the entire procedure started anew. It took twenty-six throws, twenty-six wipings of the floor, and twenty-six catchings of the cats to get a composition that I found satisfactory. The sitting—if this feverish activity could be called a "sitting"—took five hours, and at its end the photographer and his subject were more exhausted than the cats. The resulting photograph was published by *Life* and pirated

by newspapers and newsreels around the entire world.

Eventually it was included in the exhibit of "Fifty Great Photographs of the First Half of the Twentieth Century," a choice that offers a rather sad comment on the first half of this century.

P.H.

Although we were all in a state of total fatigue from this incredible photographic session, I still took the time to towel the cats dry and feed them a few cans of Portuguese sardines, which they ate with great gusto. (People were very concerned about the cats; we got very perturbed letters, especially from England.)

Y.H.

These photographs are taken from the book *Dalí's Mustache,* which was nothing but an exercise in imagination. I had only one subject, Dalí's mustache, and had to produce thirty-two interesting and unusual pictures. The book is now out of print and a collector's item. I must, however, confess that it was not entirely a publishing success. In 1954, the publishers and I had overestimated the interest of the American public in Dalí's mustache.

In my efforts to make unusual photographs of the mustache, I wanted to show it on fire or under water. The photograph of Dalí's burning mustache was not sufficiently spectacular to deserve publication, since the book had only black-and-white illustrations and one could not see the color of the flames.

To photograph the mustache under water, I asked Dalí to put his head in a glass tank filled with water. His mustache drooped and looked rather funny. But it was not enough to fill me with enthusiasm. I gave Dalí some milk, which he squirted out of his mouth when he again put his head under water. It produced a kind of atomic mushroom cloud.

P.H.

In 1986, a French publisher fell in love with *Dalí's Mustache* and reprinted it. I translated the text into French. There is also a German edition.

Y.H.

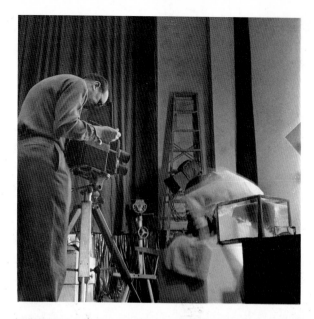

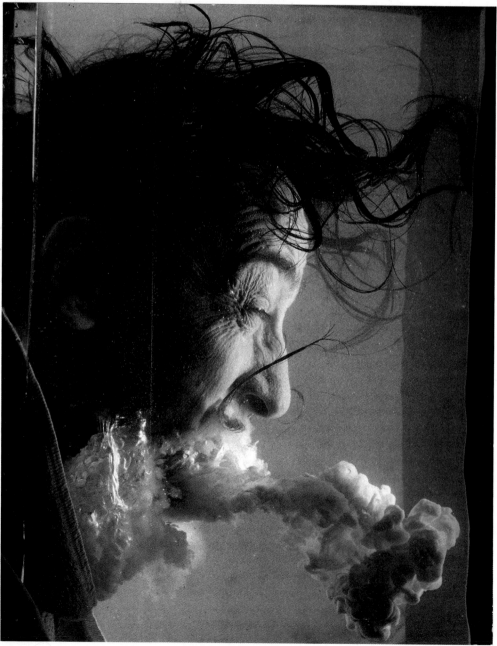

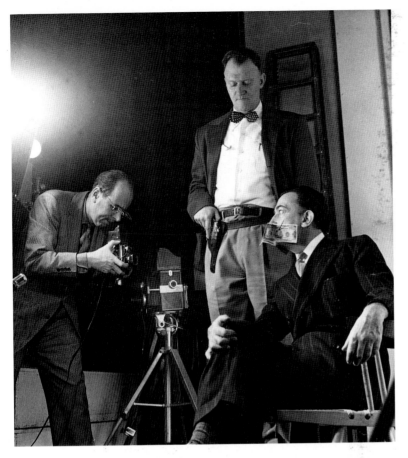

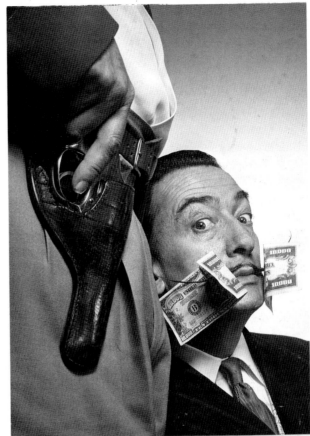

Dalí expressed the desire to be photographed with two $10,000 bills on the occasion of signing his contract with Simon & Schuster for the book *Dalí's Mustache*. Arrangements were made with the bank, and an armed guard showed up with the bills.

The question arose how to affix the bills to the famous mustache. Philippe, as always, favored the simplest solution. He reached for a sharp pointed pencil and was about to jab a hole in the center of the bills—at which point the guard objected vigorously. Philippe was not deterred: He pierced the bills with the pencil point and calmly threaded them onto the mustache. A few minutes later, I recorded the episode for posterity.

Y.H.

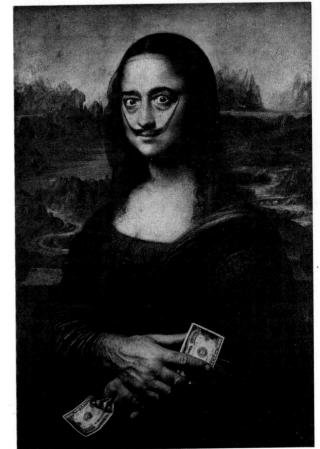

One day Dalí confided that he always wanted to look like Mona Lisa. I smiled because I never felt a remotely similar desire.

"All right," I said, "I will put your mustache on Mona Lisa's face."

"But there's one problem," cautioned Dalí, "Marcel Duchamp has already created a scandal by drawing a mustache on Mona Lisa. It would be plagiarism."

"Nonsense," I assured him. "I will also give her your piercing eyes and your big hands. And she will be counting money."

Dalí's face lit up. One of his dreams was coming true.

P.H.

In 1953, there was a competition for dress designers in which Dalí also participated. His dress was spectacular but so voluminous it could not be photographed in the studio.

First Philippe tried to shoot in the street with our daughter Jane holding the hat with the famous crutch. But even the street was too narrow.

Philippe decided to go to the roof of the Roxy Theater with the dress, the helpers, the model Toni Hollingsworth, our daughter, and a *Life* magazine researcher. It was not an easy shot, but it did capture Dalí's spirit.

Y.H.

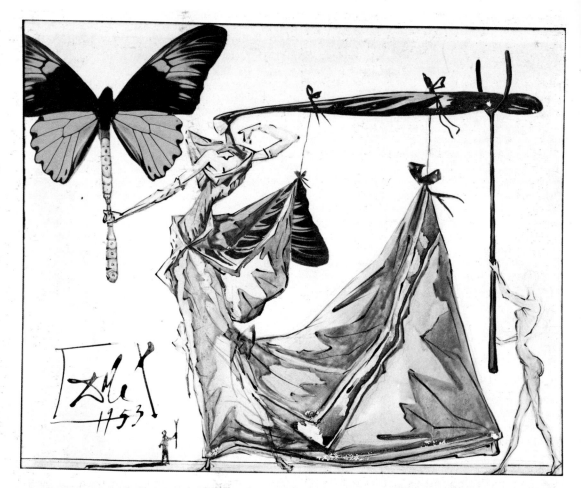

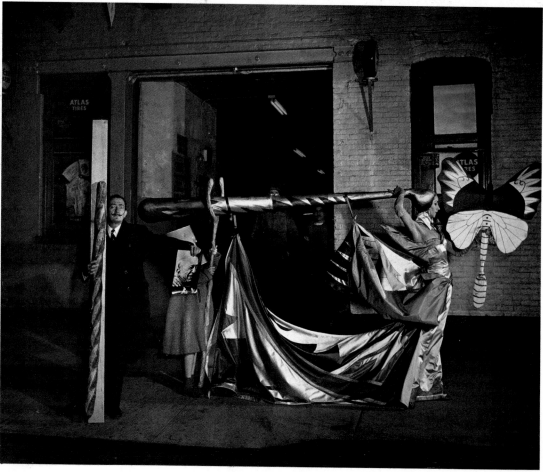

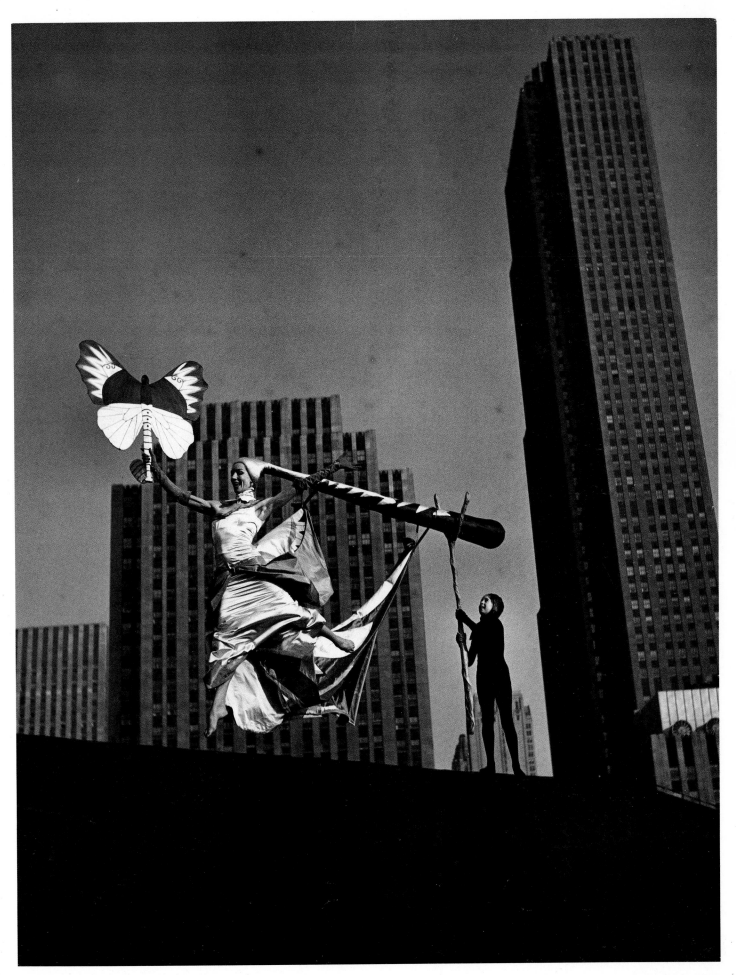

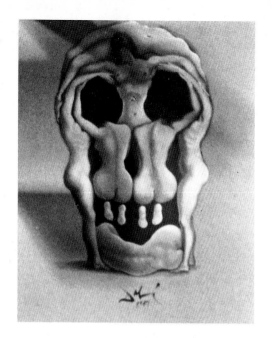

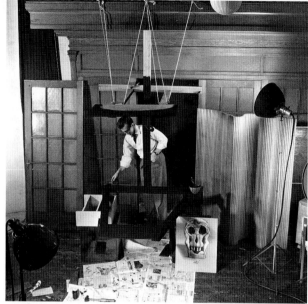

For more than thirty years Philippe and Dalí collaborated on many projects. This particular photograph came to be when they both agreed that a photograph showing a multitude of nudes would be very much appreciated by the public. The question was then to find a suitable concept.

One evening Dalí called very excitedly and said that he had found the theme for this photograph. The next day he came to the studio with his drawing of a human skull composed of seven nudes. Philippe was now faced with the challenge of translating this drawing into a photograph done with live models.

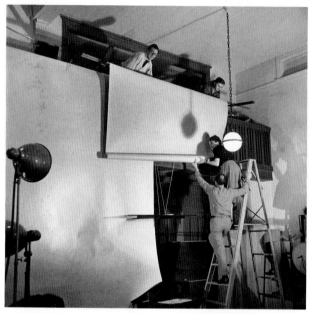

It took Philippe and Dalí a good week to choose the models. Everyday a stream of models came to the studio to be interviewed. They had to have specific measurements to fit proportionally into the architecture of the skull.

Finally everything was ready for the shooting: a specially constructed scaffold with platforms built by Philippe's able assistant, Bill Schropp (now an established photographer), the large white background paper, Dali's top hat and tails, the starch to powder the feet of the models, tall ladders, etc. There were nine nude models in the studio. We actually needed only seven, but in case someone fainted or didn't measure up to the job, we thought, to be on

ACKNOWLEDGMENTS My grateful acknowledgment and my appreciation to my children Jane Bello and Irene Halsman, to Steve Bello, and to my grandchildren, for their help and contribution. Also my special thanks to Azzielean Roberts and Marcia Schonzeit for their efficient help, and to Paul Gottlieb, Eric Himmel, and Bob McKee for having made it possible. YVONNE HALSMAN

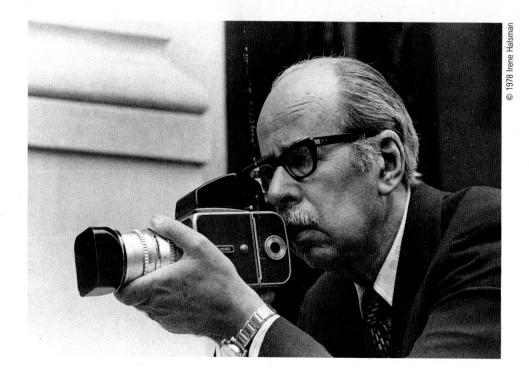

PHILIPPE HALSMAN

(1906–1979) was one of the great portrait photographers of our time. He had more *Life* magazine covers (101) to his credit than any other photographer, and three of his well-loved portraits—of Albert Einstein, Adlai Stevenson, and John Steinbeck—were used on United States postage stamps. His photograph of André Gide was used on a French stamp. His colleagues elected him as first president of the American Society of Magazine Photographers in 1944, and in 1958, he was chosen as one of the world's ten best photographers in an international poll. He was the recipient of the ASMP Life Achievement in Photography Award in 1975. Beginning in 1986, the ASMP instituted an annual Philippe Halsman Award for Photojournalism.

His work is represented in the permanent collections of numerous museums in the United States and abroad. Among his many one-man exhibitions was a retrospective that began at the International Center of Photography in New York in 1979 and continued to tour the United States until 1988.

He was on the faculty of the Famous Photographers School, and from 1970 to 1979, he taught a seminar on psychological portraiture at the New School, New York.

Halsman Portraits, published in 1983, is a survey of his contribution to the art of portraiture. *Halsman's Jump Book*, a collection of portraits of famous people jumping, first published in 1959, was reissued in 1986. Both books are published by Harry N. Abrams, Inc.

YVONNE HALSMAN

was born in Paris, the youngest daughter of the owner of the famous Moser glass factory in Czechoslovakia. She studied piano at the Conservatoire Russe in Paris but became fascinated with photography and met Philippe through her cousin, Maria Eisner Lehfeldt, who had founded a small picture agency in Paris in 1934, Alliance Photo. Philippe happened to need an apprentice, and Yvonne went to work in his Montparnasse studio, learning the craft and building her own technique. After a year, she set up her own studio and darkroom in her mother's apartment, photographing children and working on the staff of a small weekly magazine.

Meanwhile, Philippe was becoming established as the finest portraitist in Paris and called on Yvonne from time to time to help him out. This working relationship became the turning point of her life and career.

Philippe and Yvonne were married on April 1, 1937. Three years later, when the war broke out and the Germans were about to enter Paris, Philippe sent Yvonne and their baby daughter Irene to America. Through the intervention of Albert Einstein, Philippe was able to join them in New York several months later, bringing with him only one suitcase containing his camera and a dozen prints. Shortly thereafter, their second daughter Jane was born. In 1943, the Halsmans moved into a studio on West 67th Street where their work together continued for almost forty years.